ROYAL COURT

WITH

The Royal Court Theatre presents

OUR PRIVATE LIFE

by **Pedro Miguel Rozo**

translated by **Simon Scardifield**

First performance at the Royal Court Jerwood Theatre Upstairs, Sloane Square,
London on Friday 11th February 2011

OUR PRIVATE LIFE is presented as part of the International Playwrights Season:
A Genesis Foundation Project

OUR PRIVATE LIFE

by **Pedro Miguel Rozo**

translated by **Simon Scardifield**

in order of appearance
Carlos **Colin Morgan**
Sergio **Eugene O'Hare**
The Mother **Ishia Bennison**
The Father **Anthony O'Donnell**
Tania **Clare Cathcart**
The Psychiatrist **Adrian Schiller**
Joaquín **Joshua Williams**

Directed by **Lyndsey Turner**
Designer **Lizzie Clachan**
Lighting Designer **Peter Mumford**
Sound Designer **Carolyn Downing**
Casting Director **Amy Ball**
Production Manager **Tariq Rifaat**
Stage Managers **Linsey Hall, Kate McDowell**
Costume Supervisor **Kirsty Rowe**
Fight Arranger **Brett Yount**
Dialect Coach **Martin McKellan**
Stage Management Work Placement **Penny Rischmiller**
Set Built by **Object Construction Ltd**
Set Painted by **Jodie Pritchard, Charlotte Gainey**

The Royal Court and Stage Management wish to thank the following for their help with this production: Dr Neil Brener, Oscar Guardiola-Rivera.

THE COMPANY

PEDRO MIGUEL ROZO (Writer)

Pedro studied theatre arts at ASAB, the Bogotá Academy of Arts, specialising in directing. He is the founder and director of Corporación Luna, a collective with which he has staged the majority of his work as a playwright.

PRODUCTIONS WITH CORPORACIÓN LUNA INCLUDE: Solos para piano (Piano Solos); Club suicida busca... (Suicide Club Seeks...); Viceversa (Vice-Versa); Ascodeseo (Disgust-Desire).

OTHER THEATRE INCLUDES: Tálamo (Bridal Bed) and Purgatorio express (Purgatory Express).

AWARDS INCLUDE: 2009 Distrital Playwriting Competition for Nuestras Vidas Privadas, 2008 Iberescena best play award for Purgatorio expresso.

He teaches playwriting at several Colombian universities and is one of the organisers and managers of the Colombian National Playwriting Network. His theatrical work has appeared at festivals in several countries, including Spain, Uruguay, Switzerland, Brazil, Canada and France among others. His first novel "El testamento" (The Testament) was a finalist in the Álvaro Cepeda Samudio debut novel competition in 2003.

Pedro attended the Royal Court International Residency in 2009 where he developed Nuestras Vidas Privadas (Our Private Life), which has been produced in Colombia where it won the Distrital Playwriting Competition.

ISHIA BENNISON (The Mother)

THEATRE INCLUDES: Canterbury Tales (North Broadsides tour); A Couple of Poor Polish Speaking Romanians (Soho); Once We Were Mothers, Strange Orchestra, Mother Courage (Orange Tree); A New Way to Please You, Sejanus, Speaking Like Magpies, Cymbeline, Measure for Measure (RSC); Bites (Bush); Who's Afraid of Virginia Woolf? (Manchester Library); Antony and Cleopatra (New York/Stratford); Romeo and Juliet (Poland); A Midsummer Night's Dream (Brazil); Merry Wives (India); Richard III (Tower of London/Riverside Studios); Poetry or Bust, Samson Agonistes (Northern Broadsides); Arabian Nights (Young Vic); Medea (Lilian Baylis); Miriam's Flowers (Old Red Lion); Les Miserables (Nottingham Playhouse); Turcaret (Gate); Taking Steps (Bristol Old Vic); Red Devils (Liverpool Playhouse); One for the Road (Tour); Educating Rita (Oxford Playhouse & Tour).

TELEVISION INCLUDES: True Dare Kiss, Emmerdale, Hollyoaks in the City, Little Howard, At Home with the Braithwaites, Holby City III, Coronation Street, Burnside, Love Hurts, EastEnders, Story Teller, Bread, Much Ado About Nothing, 1001 Nights.

FILM INCLUDES: King David, Anno Domini, The Awakening, Jesus of Nazareth.

CLARE CATHCART (Tania)

FOR THE ROYAL COURT: Loyal Women.

OTHER THEATRE INCLUDES: The Indian Boys (RSC); Aristocrats (Chichester Festival Theatre); Gone to LA (Hampstead); Sitcom Festival (Riverside Studios); Romeo & Juliet (Greenwich Theatre); After the Rain (Gate); The Party's Over (Nottingham Playhouse); Translations (Donmar); Fooling About (Oxford Stage Co.); Cloud Nine, Duchess of Malfi (Contact Theatre); Joyriders (Tricycle).

TELEVISION INCLUDES: Tracey Beaker Returns, Come Fly With Me, The Little House, Ladies of Letters, Beautiful People, Cast Offs, Holby City, Afterlife, Ultimate Force, Gimme Gimme Gimme, Attachments, Sins, I Saw You, Psychos, Sunny Ears, Accused, Kiss and Tell, Coronation Street, Safe and Sound, The Bill, Casualty, Over Here, Searching, Father Ted, Goodnight Sweetheart, Paris, Inspector Alleyn.

FILM INCLUDES: Feast of the Goat, Cor Blimey, Breathtaking, Secret Society, Hotel Splendide. Up on the Roof, Salvage, Amazing Grace.

RADIO INCLUDES: The Other Man, Goya, A Country Dance, Law of Diminishing Returns, The Lights, Angel, Nun Climbs Tree, Le Celestina, Eamon Older Brother of Jesus, We Know Everything, Silver's City.

LIZZIE CLACHAN (Designer)

FOR THE ROYAL COURT: Aunt Dan and Lemon, The Girlfriend Experience (& Plymouth Drum); On Insomnia and Midnight (Festival Internacional Cervantino, Guanajuato & Centro Cultural Helénico, Mexico City); Woman and Scarecrow, Ladybird.

OTHER THEATRE / OPERA INCLUDES: Tiger Country (Hampstead Theatre); Far Away (Bristol Old Vic); Bliss (Staatsoper, Hamburg); Treasure Island (West End); Shoot/Get Treasure/Repeat (Paines Plough); Contains Violence, Absolute Beginners (Hammersmith Lyric); Money, Tropicana (Shunt/National); Amato Saltone, Dance Bear Dance, The Ballad of Bobby François, The Tennis Show (Shunt); Soldier's Fortune (Young Vic); Bedtime Story & The End of the Beginning (Union Theatre/Young Vic); Julie, Gobbo (National Theatre of Scotland); Factory Girls (Arcola); Ether Frolics (Shunt/Sound & Fury); I'll Be The Devil, Days of Significance, The American Pilot (RSC); All in the Timing (Peepolykus national tour); Moonstone (Royal Exchange).

Lizzie co-founded Shunt in 1998 and is an artistic director of the company.

CAROLYN DOWNING (Sound Designer)

FOR THE ROYAL COURT: Oxford Street, Alaska.

OTHER THEATRE INCLUDES: Beautiful Burnout (Frantic Assembly/NTS); Amerika, Krieg der Bilder (Staatstheater Mainz, Germany); The Gods Weep, The Winter's Tale, Pericles, Days of Significance (RSC); After Dido (ENO at Young Vic); Lower Ninth, Dimetos, Absurdia (Donmar); All My Sons (Schoenfeld Theatre, New York); Tre Kroner - Gustav III (Royal Dramatic Theatre, Sweden), Angels in America: Millennium Approaches & Perestroika (Headlong); The Talented Mr Ripley (Royal, Northampton); 3rd Ring Out (Metis Arts); Gambling (Soho); Lulu, The Kreutzer Sonata, Vanya, State Of Emergency, The Internationalist (Gate); Ghosts, Dirty Butterfly (Young Vic); After Miss Julie, Othello (Salisbury Playhouse); Moonlight & Magnolias (Tricycle); Andersen's English, Flight Path (Out Of Joint); Topdog/Underdog (Sheffield Crucible Studio); A Whistle In The Dark, Moonshed (Royal Exchange Theatre); Is That All There Is, Hysteria (Inspector Sands); Arsenic and Old Lace (Derby Playhouse); The Water Engine (Theatre 503, in association with The Young Vic); Blood Wedding (Almeida); Gone To Earth (Shared Experience); No Way Out (Huis Clos); Stallerhof (Southwark Playhouse); The Watery Part of the World (Sound and Fury).

COLIN MORGAN (Carlos)

THEATRE INCLUDES: A Prayer For My Daughter, Vernon God Little (Young Vic); All About My Mother (Old Vic).

TELEVISION INCLUDES: Merlin, Doctor Who, Catherine Tate Christmas Special.

FILM INCLUDES: Parked, Island.

RADIO: Cry Babies.

PETER MUMFORD (Lighting Designer)

FOR THE ROYAL COURT: Sucker Punch, Cock, The Seagull, Dying City (& set).

OTHER THEATRE INCLUDES: An Ideal Husband (Vaudeville); The Misanthrope, Prick Up Your Ears (Comedy); A Midsummer Night's Dream, Bedroom Farce, Miss Julie (The Rose); A View from the Bridge (Duke of York's); Pictures from an Exhibition (Young Vic); Parlour Song, Cloud Nine, Hedda Gabler, The Goat (Almeida); All's Well That Ends Well (National); Carousel, Fiddler on the Roof (Savoy); Hamlet, Brand, Macbeth (RSC); Private Lives (West End/Broadway).

OPERA & DANCE INCLUDES: E=mc2 (Birmingham Royal Ballet); Elegy for Young Lovers (ENO at The Young Vic); Petrushka, Carmen (also set), Cheating, Lying, Stealing (Scottish Ballet); Prima Donna (Manchester International Festival); La Cenerentola (Glyndebourne); Lucrezia Borgia, Faust, Bluebeard's Castle, Madame Butterfly, Così fan tutte, Die Soldaten, Poppea (ENO); Il Trovatore (Paris); La Traviata (Antwerp); Siegfried, Götterdämmerung, Fidelio, Don Giovanni (Scottish Opera); Madama Butterfly (Opera North); Giulio Cesare (Bordeaux); Carmen, Madame Butterfly, Peter Grimes, 125th Gala (Metropolitan Opera, NYC); Eugene Onegin, The Bartered Bride (ROH); Earth & the Great Weather (also directed) (Almeida Opera); L'Heure Espagnole, L'Enfant et les Sortilèges (also directed) (Opera Zuid).

TELEVISION INCLUDES: 48 Preludes & Fugues, Matthew Bourne's Swan Lake.

AWARDS INCLUDE: 1995 Olivier Award for Outstanding Achievement in Dance for The Glass Blew In (Siobhan Davies) and Fearful Symmetries (Royal Ballet), 2003 Best Lighting Olivier Award for Bacchai (National) and Knight of Illumination Award for Sucker Punch 2010.

ANTHONY O'DONNELL (The Father)

FOR THE ROYAL COURT: Cloud Nine

THEATRE INCLUDES: The Bridge Project: As You Like It/The Tempest (Old Vic); The Homecoming, King Lear, Ivanov, Dance of Death, Galileo (Almeida); Henry VII (Schtanhaus); President of an Empty Room, Cyrano, The London Cuckolds, The Way of the World, Under Milk Wood, Arturo Ui, The Miser, Ghetto, Bartholomew Fair, The Shaugraun (National); Twelfth Night, Uncle Vanya (Donmar/BAM); The Weir (Duke of York's); Glengarry Glen Ross (Donmar); All's Well That Ends Well, As You Like It, Beggar's Opera, A New Way to Pay Old Debts, Measure For Measure, Money, Peter Pan, Our Friends in the North, The Winter's Tale, Witch Of Edmonton, A Midsummer Night's Dream (RSC); Kiss Me Kate (Old Vic/Savoy).

TELEVISION INCLUDES: Gavin and Stacey, The Sarah Jane Adventure, Sweeney Todd, Much Ado About Nothing, 20,000 Streets Under the Sky, Charles II, Tess of the D'Urbervilles, Moll Flanders, The Tomorrow People, Nuts in May, Knock for Knock.

FILM INCLUDES: Caught in the Act, Death Defying Acts, The Baker, Match Point, Vera Drake, Love's Labour's Lost, Secrets and Lies, Robin Hood, Santa Claus.

EUGENE O'HARE (Sergio)

THEATRE INCLUDES: Riff Raff (Arcola); Talent (Menier Chocolate Factory); Observe the Sons of Ulster Marching Towards The Somme (Hampstead); Manifesto (RSC/Vivienne Westwood); The Caretaker (Citizen's, Glasgow); Thirst (King's Head); A Moon for the Misbegotten (Old Vic/Broadway); Lovers, War (Strindberg Theatre, Stockholm); Translations (National); Teechers (Lyric Theatre, Belfast); Memoirs of a Deadman (Edinburgh Festival); In the Sweat (Lyric, Belfast); Waiting for Godot (Grand Opera House); The Death & Resurrection of Mr Roche (Abbey, Dublin).

TELEVISION INCLUDES: 10 Days to War, Waking the Dead, Pie Days.

FILM INCLUDES: Nothing Personal, Daniel Cares, The Meeting.

RADIO INCLUDES: Translations, Red Herrings.

SIMON SCARDIFIELD (Translator)

TRANSLATIONS FOR THE ROYAL COURT INCLUDE: Used Blood Junkyard (reading).

OTHER TRANSLATIONS INCLUDE: Scorched (Old Vic Tunnels/Dialogue); Gore, Forfanteries (New Players Theatre); Danton's Death (BBC Radio 3).

LITERAL TRANSLATIONS INCLUDE: The House of Bernarda Alba by Lorca, Danton's Death by Büchner (National); Don Juan in Soho by Molière, Life is a Dream (Donmar); Blood Wedding (Almeida); Peribanez (Young Vic).

AS AN ACTOR: 1984 (Blind Summit/BAC); The Cherry Orchard (Chichester); The Lady from the Sea (Birmingham Rep); The Taming of the Shrew, Twelfth Night, Winter's Tale, Midsummer Night's Dream (Propeller/BAM/Old Vic); A Passage to India (Shared Experience); Paradise Lost (Bristol Old Vic); Twelfth Night (RSC); An Inspector Calls (National Theatre/West End).

AS DIRECTOR: Love's Labour's Lost, Amerika (E15).

ADRIAN SCHILLER (The Psychiatrist)

THEATRE INCLUDES: Every Good Boy Deserves Favour, The Hour We Knew Nothing Of Each Other, Bourgeois Gentilhomme (National); Hit Me (West End); A Christmas Carol (Rose, Kingston); The Changeling (ETT); The Taming of the Shrew (Wilton's Music Hall); Son of Man (Northern Stage); Tartuffe (Watermill, Newbury/tour); Julius Caesar, Henry V, As You Like It, Romeo & Juliet, The Tempest, Measure for Measure, Roberto Zucco, Macbeth, The White Devil, Troilus & Cressida; (RSC); Mary Stuart (Nuffield, Southampton); Madame Bovary (Shared Experience); Great Expectations (Bristol Old Vic); Macbeth (West End); Love's Labour's Lost (Regents Park); Hamlet (The Other Place); Bats (Manchester Royal Exchange); Black Comedy/The Public Eye (Palace Theatre, Watford); The Dumb Waiter (Ensemble Theatre, Vienna); The Caretaker (White Bear); Eva Peron, The Walls (The Room, Richmond); Wits End (New End Theatre); The House of Bernarda Alba, The Knickers (Lyric Hammersmith); Judgement (Café Theatre Club); The Clouds (Shaw Theatre/US tour); 1913 (Man in the Moon).

TELEVISION INCLUDES: Doctor Who, Silk, Aurelio Zen, New Tricks, Coming Up, Being Human, Going Postal, The Bill, Ashes to Ashes, The Devil's Whore, IT Crowd, Silent Witness, Suburban Shootout, Judge John Deed, Fields of Gold, Surrealissmo, My Family, Kidnapped, Bugs, Blood and Fire, Berlin Break, Prime Suspect, Wide Eyed and Legless, Sam Saturday.

FILM INCLUDES: Brighton Rock, Wild Target, Bright Star, Good, The Ten Commandments, RKO 281, Requiem Apache, Christie.

MONIQUE STERLING (Assistant Director)

AS ASSISTANT DIRECTOR FOR THE ROYAL COURT: Tribes, Spur of the Moment.

THEATRE INCLUDES: In the Solitude of Cotton Fields (The Clare, Young Vic); A Certain Child (Michael Frayn Studio); Mystical Awakening Extravaganza (BAC); Tuesday (Soho Studio); Ache (Baron's Court Theatre); Dinner Party (George Wood Theatre).

AS ASSISTANT DIRECTOR: Young NHS project (The Clare, Young Vic); Troilus and Cressida (Shakespeare's Globe); Tunnel 228 (Punchdrunk/Old Vic/Young Vic); Betting on the Dust Commander (Albany Theatre); The Worth of Thunder (Soho Studio); 2008 Schools Festival (Young Vic).

Monique is Trainee Director at the Royal Court, supported by the BBC writersroom.

LYNDSEY TURNER (Director)

FOR THE ROYAL COURT: Posh, A Miracle, Contractions.

OTHER THEATRE INCLUDES: Joseph K, Nocturnal (Gate); My Romantic History (Traverse/Sheffield Theatres/Bush); Alice (Sheffield Crucible); The Lesson (Arcola Theatre).

Lyndsey is currently an Associate Director at Sheffield Theatre and the Gate Theatre.

Previously she was Trainee Associate Director at the Royal Court and International Associate on the Royal Court International Residency for Emerging Playwrights from 2007 to 2009, where she first worked with Pedro on Our Private Life.

JOSHUA WILLIAMS (Joaquín)

THEATRE INCLUDES: Arlo (Company of Angels at Southwark Playhouse).

THE ENGLISH STAGE COMPANY
AT THE ROYAL COURT THEATRE

*'For me the theatre is really a religion or way of life.
You must decide what you feel the world is about
and what you want to say about it, so that everything
in the theatre you work in is saying the same thing
… A theatre must have a recognisable attitude. It will
have one, whether you like it or not.'*

George Devine, first artistic director of the
English Stage Company: notes for an unwritten
book.

photo: Stephen Cummiskey

As Britain's leading national company dedicated to new work, the Royal Court Theatre produces new plays of the highest quality, working with writers from all backgrounds, and asking questions about who we are and the world in which we live.

"The Royal Court has been at the centre of British cultural life for the past 50 years, an engine room for new writing and constantly transforming the theatrical culture." Stephen Daldry

Since its foundation in 1956, the Royal Court has presented premieres by almost every leading contemporary British playwright, from John Osborne's Look Back in Anger to Caryl Churchill's A Number and Tom Stoppard's Rock 'n' Roll. Just some of the other writers to have chosen the Royal Court to premiere their work include Edward Albee, John Arden, Richard Bean, Samuel Beckett, Edward Bond, Leo Butler, Jez Butterworth, Martin Crimp, Ariel Dorfman, Stella Feehily, Christopher Hampton, David Hare, Eugène Ionesco, Ann Jellicoe, Terry Johnson, Sarah Kane, David Mamet, Martin McDonagh, Conor McPherson, Joe Penhall, Lucy Prebble, Mark Ravenhill, Simon Stephens, Wole Soyinka, Polly Stenham, David Storey, Debbie Tucker Green, Arnold Wesker and Roy Williams.

"It is risky to miss a production there." Financial Times

In addition to its full-scale productions, the Royal Court also facilitates international work at a grass roots level, developing exchanges which bring young writers to Britain and sending British writers, actors and directors to work with artists around the world. The research and play development arm of the Royal Court Theatre, The Studio, finds the most exciting and diverse range of new voices in the UK. The Studio runs playwriting groups including the Young Writers Programme, Critical Mass for black, Asian and minority ethnic writers and the biennial Young Writers Festival. For further information, go to www.royalcourttheatre.com/ywp.

"Yes, the Royal Court is on a roll. Yes, Dominic Cooke has just the genius and kick that this venue needs… It's fist-bitingly exciting." Independent

INTERNATIONAL PLAYWRIGHTS AT THE ROYAL COURT

Since 1992 the Royal Court has placed a renewed emphasis on the development of international work and a creative dialogue now exists with theatre practitioners all over the world including Brazil, Cuba, France, Germany, India, Mexico, Nigeria, Palestine, Romania, Russia, Spain and Syria, and with writers from seven countries from the Near East and North Africa region. All of these development projects are supported by the Genesis Foundation and the British Council.

The Royal Court has produced new International plays through this programme since 1997, most recently Disconnect by Anupama Chandrasekhar in 2010, The Stone by Marius von Mayenburg in 2009 and Bliss by Olivier Choinière in 2008. In 2007, the Royal Court presented a season of five new international plays – The Ugly One by Marius von Mayenburg (Germany), Kebab by Gianina Carbunariu (Romania), Free Outgoing by Anupama Chandrasekhar (India), and a double bill of The Good Family by Joakim Pirinen (Sweden) and The Khomenko Family Chronicles by Natalia Vorozhbit (Ukraine). Free Outgoing by Anupama Chandrasekhar and The Ugly One by Marius von Mayenburg transferred to the Jerwood Theatre Downstairs in Summer 2008 as part of the Upstairs-Downstairs season. Other recent work includes On Insomnia and Midnight by Edgar Chías (Mexico), My Name is Rachel Corrie, edited from the writings of Rachel Corrie by Alan Rickman and Katharine Viner, Way to Heaven by Juan Mayorga (Spain), Amid the Clouds by Amir Reza Koohestani (Iran), At the Table and Almost Nothing by Marcos Barbosa (Brazil), Plasticine, Black Milk and Ladybird by Vassily Sigarev (Russia), and Terrorism and Playing the Victim by the Presnyakov Brothers (Russia).

THE ROYAL COURT IN LATIN AMERICA

The Royal Court has been working in Latin America since 2000 when Elyse Dodgson, Graham Whybrow and Roxana Silbert ran the first workshop for playwrights in São Paulo, before going on to work with emerging Brazilian playwrights in Rio de Janeiro and Salvador da Bahia. In 2003, rehearsed readings of five of the strongest new plays to have emerged from this work were presented at part of New Plays from Brazil in the Jerwood Theatre Upstairs. One of these plays, ALMOST NOTHING by Marcos Barbosa, went on to receive a full production in the same theatre in 2004, as part of a double bill with AT THE TABLE, directed by Roxana Silbert. The Brazilian director Antonio Araujo collaborated with April de Angelis on a project about London's Brazilian community in 2007 as part of the first Rough Cuts season.

A similar model was followed in Cuba, where the Royal Court has now run three different workshop groups from 2002 to 2010. This led to the Cuba Real week of readings and other events as part of the 2004 International Playwrights Season, as well as a Cuban Rough Cut in 2008.

Following the success of these projects, two new projects were started in Mexico and Colombia in 2004. There have now been three workshop groups in Mexico, all in association with the Centro Cultural Helénico in Mexico City. The first stage of the latest workshop was led by Elyse Dodgson, Jeremy Herrin and Michael Wynne in 2010. In addition, we have been running an important artistic exchange with our Mexican partner, whereby a number of Mexican playwrights have attended the International Residency at the Royal Court and three British playwrights have travelled to Mexico for a month-long residency: Mike Bartlett, Alexi Kaye Campbell and Michael Wynne. The first workshop group resulted in Arena Mexico: a week of rehearsed readings in the Jerwood Theatre Upstairs in 2006. One of these plays, ON INSOMNIA AND MIDNIGHT by Edgar Chías, was then given a full production starting at the Royal Court and then travelling to the Centro Cultural Helénico and the Festival Internacional Cervantino in Guanajuato. Much of this work in Mexico has been supported by the Anglo-Mexican Foundation.

The Genesis Foundation supports the Royal Court Theatre's International Playwrights Programme. To find and develop the next generation of professional playwrights, the Foundation funds workshops in diverse countries as well as residencies at the Royal Court. The Foundation's involvement extends to productions and rehearsed readings. The Genesis Foundation helps the Royal Court offer a springboard for young writers to greater public and critical attention. For more information, please visit www.genesisfoundation.org.uk.

OUR PRIVATE LIFE is presented as part of the International Playwrights Season, A Genesis Foundation Project, and produced by the Royal Court's International Department:

Associate Director **Elyse Dodgson**
International Projects
Manager **Chris James**
International Assistant **William Drew**

MAKING IT HAPPEN

The Royal Court develops and produces more new plays than any other national theatre in the UK. To produce such a broad and eclectic programme and all of our play development activities costs over £5 million every year. Just under half of this is met by principal funding from Arts Council England. The rest must be found from box office income, trading and financial support from private individuals, companies and charitable foundations. The Royal Court is a registered charity (231242) and grateful for every donation it receives towards its work.

You can support the theatre by joining one of its membership schemes or by making a donation towards the Writers Development Fund. The Fund underpins all of the work that the Royal Court undertakes with new and emerging playwrights across the globe, giving them the tools and opportunities to flourish.

To find out how to become involved with the Royal Court and the difference that your support could make visit www.royalcourttheatre.com/support-us or call the Development Office on 020 7565 5049.

MAJOR PARTNERSHIPS

The Royal Court is able to offer its unique playwriting and audience development programmes because of significant and longstanding partnerships with the organisations that support it.

Principal funding is received from Arts Council England. The Genesis Foundation supports the Royal Court's work with International Playwrights. Theatre Local is sponsored by Bloomberg. The Jerwood Charitable Foundation supports new plays by playwrights through the Jerwood New Playwrights series. The Artistic Director's Chair is supported by a lead grant from The Peter Jay Sharp Foundation, contributing to the activities of the Artistic Director's office. Over the past ten years the BBC has supported the Gerald Chapman Fund for directors.

DEVELOPMENT ADVOCATES

Supported by
ARTS COUNCIL ENGLAND

PROGRAMME SUPPORTERS

PUBLIC FUNDING
Arts Council England, London
British Council
European Commission
Representation in the UK
New Deal of the Mind

CHARITABLE DONATIONS
American Friends of the Royal Court Theatre
The Brim Foundation*
Gerald Chapman Fund
City Bridge Trust
Columbia Foundation
Cowley Charitable Trust
The Dorset Foundation
Do Well Foundation Ltd*
The Edmond de Rothschild Foundation*
The John Ellerman Foundation
The Epstein Parton Foundation*
The Eranda Foundation
Frederick Loewe Foundation*
Genesis Foundation
The Golden Bottle Trust
The Goldsmiths' Company
The H & G de Freitas Charitable Trust
Haberdashers' Company
Jerwood Charitable Foundation
John Thaw Foundation
John Lyon's Charity
J Paul Getty Jnr Charitable Trust
The Laura Pels Foundation*
Leathersellers' Company
Marina Kleinwort Charitable Trust
The Martin Bowley Charitable Trust
The Andrew W. Mellon Foundation
Paul Hamlyn Foundation
Jerome Robbins Foundation*
Rose Foundation
Rosenkranz Foundation
Royal Victoria Hall Foundation
The Peter Jay Sharp Foundation*
The Steel Charitable Trust

CORPORATE SUPPORTERS & SPONSORS
BBC
Bloomberg
Coutts & Co
Ecosse Films
French Wines
Grey London
Gymbox
Kudos Film & Television
MAC
Moët & Chandon
Smythson of Bond Street

BUSINESS ASSOCIATES, MEMBERS & BENEFACTORS
Auerbach & Steele Opticians
Bank of America Merrill Lynch
Hugo Boss
Lazard
Oberon Books
Vanity Fair

INDIVIDUAL MEMBERS
ICE-BREAKERS
Anonymous
Rosemary Alexander
Lisa & Andrew Barnett
Mrs Renate Blackwood
Ossi & Paul Burger
Mrs Helena Butler
Lindsey Carlon
Mr Claes Hesselgren & Mrs Jane Collins
Mark & Tobey Dichter
Ms P Dolphin
Elizabeth & James Downing
Virginia Finegold
Charlotte & Nick Fraser
Mark & Rebecca Goldbart
Alastair & Lynwen Gibbons
Mr & Mrs Green
Sebastian & Rachel Grigg
Mrs Hattrell
Stephen & Candice Hurwitz
Mrs R Jay
David Lanch
Yasmine Lever
Colette & Peter Levy
Watcyn Lewis
Mr & Mrs Peter Lord
David Marks QC
Nicola McFarland
Jonathan & Edward Mills
Ann Norman-Butler
Emma O'Donoghue
Mrs Georgia Oetker
Janet & Michael Orr
Pauline Pinder
Mr & Mrs William Poeton
The Really Useful Group
Mr & Mrs Tim Reid
Lois Sieff OBE
Nick & Louise Steidl
Torsten Thiele
Laura & Stephen Zimmerman

GROUND-BREAKERS
Anonymous
Moira Andreae
Nick Archdale
Charlotte Asprey
Jane Attias*
Caroline Baker
Brian Balfour-Oatts
Elizabeth & Adam Bandeen
Ray Barrell
Dr Kate Best
Philip Blackwell
Stan & Val Bond
Neil & Sarah Brener

Miss Deborah Brett
Sindy & Jonathan Caplan
Gavin & Lesley Casey
Sarah & Philippe Chappatte
Tim & Caroline Clark
Carole & Neville Conrad
Kay Ellen Consolver
Clyde Cooper
Ian & Caroline Cormack
Mr & Mrs Cross
Andrew & Amanda Cryer
Alison Davies
Noel De Keyzer
Rob & Cherry Dickins
Denise & Randolph Dumas
Robyn Durie
Glenn & Phyllida Earle
Margaret Exley CBE
Allie Esiri
Celeste & Peter Fenichel
Margy Fenwick
Tim Fosberry
The Edwin Fox Foundation
John Garfield
Beverley Gee
Mr & Mrs Georgiades
Nick & Julie Gould
Lord & Lady Grabiner
Richard & Marcia Grand*
Nick Gray
Reade & Elizabeth Griffith
Don & Sue Guiney
Jill Hackel & Andrzej Zarzycki
Douglas & Mary Hampson
Sally Hampton
Sam & Caroline Haubold
Anoushka Healy
Mr & Mrs J Hewett
Gordon Holmes
The David Hyman Charitable Trust
Mrs Madeleine Inkin
Nicholas Jones
Nicholas Josefowitz
Dr Evi Kaplanis
David P Kaskel & Christopher A Teano
Vincent & Amanda Keaveny
Peter & Maria Kellner*
Steve Kingshott
Mrs Joan Kingsley &
Mr Philip Kingsley
Mr & Mrs Pawel Kisielewski
Maria Lam
Larry & Peggy Levy
Daisy & Richard Littler
Kathryn Ludlow
David & Elizabeth Miles
Barbara Minto
Ann & Gavin Neath CBE
The North Street Trust
Murray North
Clive & Annie Norton
William Plapinger & Cassie Murray*
Andrea & Hilary Ponti
Wendy & Philip Press

Serena Prest
Julie Ritter
Paul & Gill Robinson
Mark & Tricia Robinson
Paul & Jill Ruddock
William & Hilary Russell
Julie & Bill Ryan
Sally & Anthony Salz
Bhags Sharma
Mrs Doris Sherwood
The Michael & Melanie Sherwood Foundation
Tom Siebens & Mimi Parsons
Anthony Simpson & Susan Boster
Richard Simpson
Brian D Smith
Samantha & Darren Smith
The Ulrich Family
The Ury Trust
Mr & Mrs Nick Wheeler
Sian & Matthew Westerman
Carol Woolton
Katherine & Michael Yates*

BOUNDARY-BREAKERS
Katie Bradford
Lydia & Manfred Gorvy
Ms Alex Joffe
Emma Marsh

MOVER-SHAKERS
Anonymous
John and Annoushka Ayton
Cas & Philip Donald
Lloyd & Sarah Dorfman
Duncan Matthews QC
The David & Elaine Potter Foundation
Ian & Carol Sellars
Edgar & Judith Wallner

HISTORY-MAKERS
Eric Abraham & Sigrid Rausing
Miles Morland

MAJOR DONORS
Rob & Siri Cope
Daniel & Joanna Friel
Jack & Linda Keenan*
Deborah & Stephen Marquardt
Lady Sainsbury of Turville
NoraLee & Jon Sedmak*
Jan & Michael Topham
The Williams Charitable Trust

*Supporters of the American Friends of the Royal Court (AFRCT)

FOR THE ROYAL COURT

Royal Court Theatre, Sloane Square, London SW1W 8AS
Tel: 020 7565 5050 Fax: 020 7565 5001
info@royalcourttheatre.com, www.royalcourttheatre.com

Artistic Director **Dominic Cooke**
Deputy Artistic Director **Jeremy Herrin**
Associate Director **Sacha Wares***
Artistic Associate **Emily McLaughlin***
Diversity Associate **Ola Animashawun***
Education Associate **Lynne Gagliano***
Producer **Vanessa Stone***
Trainee Director **Monique Sterling**‡
PA to the Artistic Director **David Nock**

Literary Manager **Christopher Campbell**
Senior Reader **Nicola Wass****
Literary Assistant **Marcelo Dos Santos**
Studio Administrator **Clare McQuillan**
Writers' Tutor **Leo Butler***
Pearson Playwright **DC Moore**^

Associate Director International **Elyse Dodgson**
International Projects Manager **Chris James**
International Assistant **William Drew**

Casting Director (Maternity Cover) **Julia Horan**
Casting Director **Amy Ball**
Casting Assistant **Lotte Hines**

Head of Production **Paul Handley**
JTU Production Manager **Tariq Rifaat**
Production Administrator **Sarah Davies**
Head of Lighting **Matt Drury**
Lighting Deputy **Stephen Andrews**
Lighting Assistants **Katie Pitt, Jack Williams**
Lighting Board Operator **Jack Champion**
Head of Stage **Steven Stickler**
Stage Deputy **Dan Lockett**
Stage Chargehand **Lee Crimmen**
Chargehand Carpenter **Richard Martin**
Building & Productions Assistant **Jerome Jones**
Head of Sound **David McSeveney**
Sound Deputy **Alex Caplen**
Sound Operator **Sam Charleston**
Head of Costume **Iona Kenrick**
Costume Deputy **Jackie Orton**
Wardrobe Assistant **Pam Anson**

Executive Director **Kate Horton**
Head of Finance & Administration **Helen Perryer**
Senior Finance & Administration Officer
Martin Wheeler
Finance Officer **Rachel Harrison***
Finance & Administration Assistant **Tessa Rivers**
Administrative Assistant **Holly Handel**

Head of Communications **Kym Bartlett**
Marketing Manager **Becky Wootton**
Press & Public Relations Officer **Anna Evans**
Communications Assistant **Ruth Hawkins**
Communications Interns **Alexandra Dewdney,
Alice Newton**

Sales Manager **Kevin West**
Box Office Sales Assistants **Ciara O'Toole, Stephen
Laughton***, **Helen Murray***, **Amanda Wilkin***

Head of Development **Gaby Styles**
Senior Development Manager **Hannah Clifford**
Development Manager **Lucy Buxton**
Development Assistants **Penny Saward, Anna Clark**
General Fundraising Assistant **Beejal Pandya**

Theatre Manager **Bobbie Stokes**
Deputy Theatre Manager **Daniel O'Neill**
Duty Managers **Fiona Clift***, **Claire Simpson***
Events Manager **Joanna Ostrom**
Bar & Food Manager **Sami Rifaat**
Bar & Food Supervisors **Ali Christian**, **Becca Walton**
Head Chef **Charlie Brookman**
Sous Chef **Paulinho Chuitcheu**
Bookshop Manager **Simon David**
Assistant Bookshop Manager **Edin Suljic***
Bookshop Assistant **Vanessa Hammick** *
Customer Service Assistant **Deirdre Lennon***
Stage Door/Reception **Simon David***, **Paul
Lovegrove, Tyrone Lucas**

Thanks to all of our box office assistants, ushers and bar staff.

^ This theatre has the support of the Pearson Playwrights' Scheme
sponsored by the Peggy Ramsay Foundation.

** The post of Senior Reader is supported by NoraLee & Jon
Sedmak through the American Friends of the Royal Court Theatre.

‡The post of the Trainee Director is supported by the BBC
writersroom.

* Part-time.

ENGLISH STAGE COMPANY

President
Dame Joan Plowright CBE

Honorary Council
Sir Richard Eyre CBE
Alan Grieve CBE
Martin Paisner CBE

Council
Chairman **Anthony Burton**
Vice Chairman **Graham Devlin CBE**

Members
Jennette Arnold OBE
Judy Daish
Sir David Green KCMG
Joyce Hytner OBE
Stephen Jeffreys
Wasfi Kani OBE
Phyllida Lloyd CBE
James Midgley
Sophie Okonedo OBE
Alan Rickman
Anita Scott
Katharine Viner
Stewart Wood

OUR PRIVATE LIFE

Pedro Miguel Rozo

OUR PRIVATE LIFE

A family parable in three acts and an epilogue

Translated by Simon Scardifield

OBERON BOOKS
LONDON

First published in 2011 by Oberon Books Ltd
521 Caledonian Road, London N7 9RH
Tel: 020 7607 3637 / Fax: 020 7607 3629
e-mail: info@oberonbooks.com
www.oberonbooks.com

A catalogue record for this book is available from the British
Library.

ISBN: 978-1-84943-089-0

Cover artwork by Nate Williams.

Printed in Great Britain by CPI Antony Rowe, Chippenham.

Characters

CARLOS

SERGIO

THE FATHER

THE MOTHER

TANIA

THE PSYCHIATRIST

JOAQUÍN

Location: A town with the soul of a village, or a village with the body of a town.

FIRST ACT

CARLOS: I knew it. I've always had this horrible feeling there was something wrong with our family. There must be, mustn't there, if it produced someone like me.

SERGIO: Did you say something?

CARLOS: Nothing. Talking and thinking are the same thing here.

SERGIO: That's village life for you… But it's all going to change soon.

CARLOS: It's late. You were asleep. Did I wake you?

SERGIO: Why are you calling?

CARLOS: Do you know what dad's done?

SERGIO: Are you talking or thinking?

CARLOS: Why do you want to know?

SERGIO: Well are you expecting an answer.

CARLOS: I was talking.

SERGIO: Then I'll answer. I've no idea.

CARLOS: Dad fiddled with this kid and got caught. He's going to prison.

SERGIO: Don't talk so loud.

CARLOS: Don't worry. Mum and dad don't have sex any more, they're dead to the world.

SERGIO: Let's talk another time. My wife's asleep and being pregnant makes her irritable.

CARLOS: You and me are never going to sleep well again after this.

SERGIO: Bye.

CARLOS: It was Tania's son, the woman who used to live on the farm.

SERGIO: Who was?

CARLOS: The kid dad fiddled with.

SERGIO: It's not even original. You'd know that if you watched any television on bank holiday afternoons.

CARLOS: All I do on bank holiday afternoons is get depressed.

SERGIO: Course you do. You should get married. He should get married.

CARLOS: To have kids I can fiddle with?

SERGIO: Why don't you go to bed and let me get some sleep?

CARLOS: Sergio, did dad used to touch me?

SERGIO: Carlos…

CARLOS: If he could have a go at the farm-hand's son then he could just as well have tried it on with me. Did he used to touch me?

SERGIO: What?

CARLOS: You're older than me. You must remember something.

SERGIO: No.

CARLOS: Tell me my dad used to touch me. You know he did. Just say it. I know he used to do it. I've got a right to know.

SERGIO: Dad didn't do anything. Dad didn't touch anyone. Dad's going to keep on living with mum and you, taking walks through the bamboo groves on Sundays, thinking about all the money he had before he lost it and hating me for not turning out the way he wanted.

CARLOS: Fine then. I made it all up.

SERGIO: Right, so shut up then.

CARLOS: I've shut up.

Pause.

SERGIO: Where did you get a story like that?

CARLOS: My boss at the grill told me. There are rumours. I can't deal with this, not on my own. You're strong. You can help me. You're the older brother, your wife's pregnant, you earn good money, you're intelligent, you don't fancy men and you're Catholic.

SERGIO: Thanks.

CARLOS: I had that horrible dream again last night.

SERGIO: Carlos…

CARLOS: They were going to put dad in prison and…

SERGIO: Why don't you shut up?

CARLOS: You're right. He's right. Better to wrap myself up in a silence like a plastic bag over my head. Die young and come back as a stone that sits at the bottom of a deep deep river and feel all the bad karma from this life getting washed away. I don't say anything and he sits there listening to me saying nothing down the phone, he knows there's something on my mind, he knows things aren't as simple as they seem and I…

SERGIO: I'm going to hang up.

CARLOS: No.

SERGIO: I have to be at work at seven tomorrow.

CARLOS: I can't sleep.

SERGIO: Then slip into a pair of heels and go out for a cigarette on the Plaza Bolívar.

CARLOS: The village isn't safe at night any more.

SERGIO: It's not a village. We're growing, we're opening a shopping centre where people will go to take photos of each other riding on escalators for the first time in their lives and buying everything they need to make them feel less like the peasants they are.

CARLOS: I'm going to kill myself!

SERGIO: Because dad abused you? Very original.

CARLOS: I don't like life. I'm not like you.

SERGIO: You're right. He's right. I'm right. I like life. I'm not going to kill myself. I'm not going to turn into a character off some bank holiday afternoon film.

CARLOS: Dad must have abused me when I was a boy. He must have tried to put it up me one time when we were walking by the river and that must have occasioned an acute psychological trauma in me. Hello? Hello? You haven't hung up. I know you haven't hung up. You're pretending you're not there so you can hear what I'm saying when I don't think you're listening. Because you do care about me in the end, actually. Sergio. I'm going to kill myself. I mean it this time. Sergio. Sergio. I'm serious. Dad is a pervert. Hello? I'm going to tell mum. Is dad in?

THE MOTHER: He went out. I don't know where. But he said he wouldn't be long. Can you water the plants?

CARLOS: Mum, I had a horrible dream last night.

THE MOTHER: You mustn't stop taking the lithium, sweetheart.

CARLOS: It wasn't that.

THE MOTHER: Then find yourself a boyfriend. I've reconciled myself to the pain, you know. We have to take our children as they are. I coped with the chemo, and if I can do that then I can cope with seeing you with a boyfriend, can't I? I'm an understanding mother. Find yourself a boyfriend and be happy. You can bring him round for lunch on Sundays. I can do us a nice mondongo. As a family.

CARLOS: I hate mondongo.

THE MOTHER: Really?

CARLOS: I've always hated it.

THE MOTHER: Sancocho then.

CARLOS: Mum, I'm vegetarian.

THE MOTHER: No wonder you're miserable. You're not eating anything.

CARLOS: We need to talk about dad.

THE MOTHER: No.

CARLOS: I'll talk to him then.

THE MOTHER: No. What father wants to find out his son is a homosexual? I'm different, I'm a modern, sophisticated sort of woman, I've had cancer, I can cope with anything, but don't do that to your father.

CARLOS: I'm not going to come out to him, mum.

THE MOTHER: Well good. He's been ever so uptight lately…

CARLOS: Why?

THE MOTHER: He's getting deeper and deeper into debt and he won't sell that stupid little farm that's only good for losing money and getting all depressed about though goodness knows why.

CARLOS: My dad's a rapist but I don't know how to tell her.

THE MOTHER: I'd rather you thought more quietly.

CARLOS: I can't.

THE MOTHER: Then put on that Richard Clayderman CD Sergio gave me.

CARLOS: I dreamed that I was making love to dad in a prison cell.

THE MOTHER: Could you start laying the table?

CARLOS: Mother…

THE MOTHER: And the avocado.

CARLOS: Mum!

THE MOTHER: Don't you shout at me. I can still give you a good slap. Just you show some respect. I'm still your mother.

CARLOS: I…

THE MOTHER: Keep your mouth shut, lay the table, fetch the avocado and switch your thoughts off.

CARLOS: Dad…

THE MOTHER: What did we do wrong? Were we really such bad parents that we deserve this?

CARLOS: No.

THE MOTHER: Don't answer, I'm thinking! The other day I read a thing on the internet about a boy who burned his parents alive to pay them back for all the trauma he'd suffered as a child.

CARLOS: Finished?

THE MOTHER: Yes. You wouldn't do anything to hurt your mother would you, treasure?

CARLOS: Are we on the internet now?

THE MOTHER: Only in my room. Sergio said. He doesn't want you getting addicted to porn.

CARLOS: I didn't know.

THE MOTHER: You're never at home. Unlimited use. Where would I be without your brother? He's done so well with the new shopping centre. The biggest in the area. It's going

to have escalators, like the ones in the adverts for the flat-screen TV he's going to buy me, just imagine.

CARLOS: Mum, dad tried to rape Tania's son.

THE MOTHER: Tania?

CARLOS: The woman who used to work for dad. Edgar said he's been indicted.

THE MOTHER: They should double your lithium dose.

CARLOS: This time it's true. It's all true.

THE MOTHER: Like the witch who used to chew your arms while you were asleep?

CARLOS: This time…

THE MOTHER: Like the paramilitaries who kidnapped you for a whole weekend?

CARLOS: It's true…

THE MOTHER: Like the teacher who made you kneel on bottle-tops? Like the fried fish that whispered "don't eat me"? Or the banshee that appeared to you in the river in the middle of the night? Or the machete that jumped off the wall and cut your arm?

CARLOS: It's all true!

THE MOTHER: It hasn't been easy being your mother, Carlos, not easy at all.

CARLOS: Being dad's son isn't easy either!

THE MOTHER: You don't know the difference between truth and lies. It's not me saying that, it's your doctor. And doctors know things. In case you'd forgotten, you're a 'bipolar compulsive fantasist'. Where are the love and faith we taught you? Life is a question of faith. Haven't you been back to church?

CARLOS: Back? I've never been to church, mum.

THE MOTHER: That's not true. I had you baptized. I remember it clear as anything.

CARLOS: Well I don't. There are lots of things about my childhood I don't remember and I don't know if I want to.

THE MOTHER: Don't talk like that.

CARLOS: I'm not talking.

THE MOTHER: Don't think then. The other day I saw a film about a boy who was obsessed with his childhood and at the end he locked his parents in the kitchen and turned on the gas.

CARLOS: Mum…

THE MOTHER: That's films for you. At any rate I'm having the electric stove put back in. I'm a modern woman but I could never get used to gas, and this way if there is another earthquake we'll be spared the sight of our limbs flying through the air in slow-motion and then landing in the rubble all mixed up with bits of our neighbours who are not as well off as we are. So we're going back to electric. Better safe than sorry. Take your lithium, love, go back to your therapy, stop telling fibs, don't think out loud, get a boyfriend and hold on to the job at the grill.

CARLOS: It's horrible. All I do all day is watch people sinking their teeth into the corpses of dead animals.

THE MOTHER: You could get a job at a greengrocer's.

CARLOS: What do you know?

THE MOTHER: About selling fruit and veg?

CARLOS: About my childhood.

THE MOTHER: Nothing. I've told you, I don't like you talking like that. What's your childhood got to do with anything? You're twenty years old…

CARLOS: Twenty-two…

THE MOTHER: Twenty-two? Time flies. It's seven already, sweetheart. I'm hungry, you don't eat tuna and your father will be home any minute. Bye. Carlos can't join us, he said he'd be back late.

THE FATHER: Lucky for some. I wouldn't have minded getting back late and finding her asleep already.

THE MOTHER: I can hear him, but I'll pretend not to because I don't like to make him feel bad. Carlos has stopped his therapy and his lies are worse than ever.

THE FATHER: Would you deny a man the use of his imagination?

THE MOTHER: He's gone too far this time…

THE FATHER: Why are you always looking for trauma where there isn't any? Carlos is sensitive. Things affect him. Not like that other idiot who only ever thinks about money.

THE MOTHER: If it weren't for him we couldn't pay the mortgage.

THE FATHER: If it weren't for him I wouldn't feel like a failure.

THE MOTHER: Are you thinking or speaking? Is he thinking or speaking? Am I thinking or speaking?

THE FATHER: Does it make any difference?

THE MOTHER: Sergio is a model son.

THE FATHER: He'll still end up a wreck, same as me. Doing his duty just for the sake of doing it. Getting bored of all the things he thought would make him happy. Finding out that everything he's fought for is pointless. Always buying trousers in the same colour. Doing everything out of habit because that's all there is left. Everything else just goes, it frustrates you, it dies, it disappears out the back door to the bins, like my one-hectare farm and my sex-drive, with or without Viagra.

THE MOTHER: But Sergio's different…

THE FATHER: Of course he is. I know what he is and what he isn't.

Pause.

THE MOTHER: I read an article on the internet today about a man of sixty who repeatedly raped his son.

THE FATHER: How old was the son?

THE MOTHER: Eleven or twelve, I can't remember.

THE FATHER: In that case he liked it. A twelve-year-old is twice as strong as a man of sixty.

THE MOTHER: You're in good shape at the moment. I mean, you're jogging in the mornings again, aren't you?

THE FATHER: I've stopped all that. There's nowhere to go – there are too many people in this bloody village.

THE MOTHER: We are not a village. We're getting a shopping centre. The town's changing. For the better. The whole country is. It's safer these days. We've got strong institutions.

THE FATHER: We've got what? Where did you pick that up?

THE MOTHER: And we trust in them. We know the difference between good people and bad people. We hate terrorism. We believe in our country again.

THE FATHER: We should never have abandoned the farm.

THE MOTHER: We haven't abandoned it. You go there once a week.

THE FATHER: Not recently.

THE MOTHER: Good. Even that was too much if you ask me.

THE FATHER: Why can't anything be like it was before?

THE MOTHER: If only you'd sell up we could…

THE FATHER: ...spend our weekends shut up in here watching films on the DVD player your son gave us?

THE MOTHER: They've having the scan tomorrow.

THE FATHER: I hope it's a boy.

Pause.

THE MOTHER: Why?

THE FATHER: I like boys.

Pause.

THE MOTHER: We've run out of cockroach powder. I'll have to get some tomorrow.

THE FATHER: I mean carrying on the family name is the least Sergio could do, after everything I've done for him. Though I'd have preferred a grandson from Carlos.

THE MOTHER: He's never had any luck with the girls.

THE FATHER: I'd much rather have one by him than by that bastard.

THE MOTHER: You know I was watching a film yesterday about a family that was the most upright, respectable, honest in the whole of this city somewhere and this awful rumour started and it completely ruined their reputation.

Pause.

THE FATHER: A rumour... about what?

THE MOTHER: I don't remember. Doesn't matter. Aren't you going to eat any more?

THE FATHER: No. See you tomorrow.

THE MOTHER: Happy anniversary, love. Everyone thinks it's amazing we've been together thirty years.

THE FATHER: I'm not having breakfast tomorrow. I have to make an early start.

THE MOTHER: Why?

THE FATHER: I have to make an early start. See you tomorrow.

THE MOTHER: I was watching this documentary about divorce the other day and they were saying that one in two marriages fails after three years. Isn't that awful?

Pause.

THE MOTHER: Oh well, sex isn't the be all and end all, is it.

THE FATHER: How much do you want?

TANIA: I suppose you think that's the answer to everything.

THE FATHER: No. But my eldest does, and this one's no different.

TANIA: Go fuck yourself!

THE FATHER: We don't have to resort to that, let's talk like adults. This house is only small, you can hear everything…

TANIA: Not like on the farm, lovely and big there.

THE FATHER: One hectare. A hectare it took me twenty years to get going only to watch you turn it into a heap of weeds. I only used to go Saturdays and now I don't go at all, I just want to forget about everything.

TANIA: You weren't stupid, were you, sending me off for stuff from the village so you could be alone with my boy.

THE FATHER: Things from the market to make sure he'd eat well.

TANIA: Make sure he's looking all nice and sleek.

THE FATHER: I like helping children.

TANIA: I know you do.

THE FATHER: You know nothing about it. You hate your son.

TANIA: Fuck off!

THE FATHER: Joaquín told me you used to beat him.

TANIA: Because he drives me round the fucking bend sometimes, not because I hate him.

THE FATHER: I taught him to read and write: you wouldn't take him to school.

TANIA: You don't need school to learn how to do the weeding and give your mum's boss a nice smile.

THE FATHER: It's disgusting.

TANIA: No, you're disgusting.

THE FATHER: How much do I have to give you to put a stop to this rumour?

TANIA: "Neither shall you take a bribe, for a bribe blinds even the most clear-sighted and twists the words even of the just."

THE FATHER: I don't watch soaps.

TANIA: Exodus chapter 23, verse 1.

THE FATHER: I'm not a Jehovah's Witness.

TANIA: I know. That's how you can do what you do.

THE FATHER: It's your word against mine.

TANIA: And in the eyes of the law mine isn't worth shit.

THE FATHER: Because you've got no proof.

TANIA: I've got my son's statement: you grabbed him by force, if he hadn't struggled to get free you'd have fucked him, no trouble. God knows how many times you already have.

THE FATHER: So why didn't the forensic people find any trace of this struggle on either of us?

TANIA: Because in this country nobody gives a fuck what a poor person says. I swear to God if we had money the police would never have closed the case.

THE FATHER: Swearing in vain is a sin.

TANIA: Fuck you.

THE FATHER: Don't you care about your son's feelings? He won't be able to go anywhere without people pointing at him. It'll traumatize him.

TANIA: He's already traumatized, you've seen to that.

THE FATHER: I didn't do anything. The boy came to fetch a ball that had got left behind after the move.

TANIA: …because you'd thrown us out like dogs the week before with no time to pack.

THE FATHER: He got his trousers dirty, he tried to wash them in the trough, then off he went. That was it. I didn't touch a hair on his head.

TANIA: So why did Joaquín say you grabbed him and tried to make him touch your cock?

THE FATHER: I haven't a clue.

TANIA: You fucking queer.

THE FATHER: I am not a queer. You show me some respect!

TANIA: I should have realized before all this happened. I'm an idiot. Why didn't I realize before? Why am I asking that? Why is it painful to ask it?

THE FATHER: You mad old bat. You're brain-washing him.

TANIA: He's my son.

THE FATHER: You're just trying to get your own back for being chucked off the farm.

TANIA: You only chucked me off because you were afraid my son was going to talk.

THE FATHER: But that doesn't make sense. I throw you out, a week later he comes to get his ball, and it's only then that…

TANIA: You'd been fiddling around with my son for ages, of course you had, then you got scared I'd find out so you chucked me off.

THE FATHER: I got rid of you because I couldn't keep someone on whose failure to spray the plantains ruined the whole crop and left me in the financial ruin I'm facing now. You know very well I'm innocent. I never abused the boy. I chucked you off because you're a useless worker.

TANIA: It was too much for me on my own.

THE FATHER: Your son's a man, he'll be thirteen soon. He could have helped.

TANIA: What, helped you get hard?

THE FATHER: Listen, Tania: Do you really think I could get the better of a boy of twelve? You don't think he'd have given me a good kick if I'd tried to do anything to him?

TANIA: Maybe he did.

THE FATHER: In that case why didn't the doctor find any marks?

TANIA: If nothing happened why are you so keen to shut me up?

THE FATHER: Because I want to live in peace without people thinking I'm a monster, is that too much to ask?

Pause.

TANIA: I want fifteen million pesos.

THE FATHER: How much?

TANIA: I know you've got it.

THE FATHER: I don't have a pension and you know better than anyone the farm's good for nothing any more.

TANIA: Sell it.

THE FATHER: So that some city type can buy it for peanuts to get pissed in at weekends? No, thank you. Come up with a more reasonable offer and call me. And think it through this time. If you get greedy you'll ruin everything. Yes, I'm a coward, I admit it, and I care about what people think of me, but not to the tune of fifteen million. If I was guilty I'd cough up straight away, but to clear my name when we both know I'm innocent, it's too much. Look, you've found a way of fleecing me in broad daylight, so do it sensibly or you'll end up with nothing.

TANIA: Fuck you.

THE FATHER: Call me when you've made your mind up. Carlos, you turn me on, I want to keep on putting my tongue up your little arse while the prison guard looks on and gets hard…

CARLOS: … And the dream carries on, but I can't ever remember the next bit.

THE PSYCHIATRIST: You can't remember or it's painful to talk about?

CARLOS: It hurts to remember it. That's the frightening thing. I get confused. I can't tell the difference between memories and dreams.

THE PSYCHIATRIST: Have you had any other recurring dreams?

CARLOS: Have you heard the rumour?

THE PSYCHIATRIST: Rumour?

CARLOS: My dad tried to rape a boy.

THE PSYCHIATRIST: When a patient such as yourself interrupts their course of lithium it can occasion a serious disturbance in the brain's fantasy and oneiric activity.

CARLOS: There was this woman who used to work on the farm. Did everything. It was her son.

THE PSYCHIATRIST: That's a nice bit of land. It'd fetch a good price. Some rich weekender would snap it up in a heartbeat. Tourism's where it's at these days.

CARLOS: I need to know whether my dad has ever tried that kind of thing in the past. I want to know if he did it to me.

THE PSYCHIATRIST: You need to get yourself back on your medication and then next week we can see whether...

CARLOS: You're a psychiatrist. Put me under hypnosis and tell me, did he or didn't he?

THE PSYCHIATRIST: It's not as easy as you think. It's a long and far-reaching process. Long, above all. We have to start by analyzing the psychodynamic structure of what you're saying here. This is just the tip of the iceberg.

CARLOS: So?

THE PSYCHIATRIST: So you need to get back on board with your treatment, I'm afraid. We can't access a truth of that nature overnight. Tell me what you got up to yesterday.

CARLOS: I was working at the grill. I was doing some beef, some bits of baby cow, and I just burst into tears. I'm very sensitive. Then I went to the bank to get the money for the session with you.

THE PSYCHIATRIST: Is your brother still paying?

CARLOS: Yes, he's the manager of the new shopping centre they're opening at Christmas, he earns a lot of money, he's Catholic and his wife is pregnant.

THE PSYCHIATRIST: You'd have liked a life like his.

CARLOS: I'm not sure any more. It's risky, wanting to be like my brother. Who's to say dad didn't take his cherry when he was five. It's hard not knowing if you should be envying someone or not.

THE PSYCHIATRIST: Do you want to see your father in prison like he is in your dreams?

CARLOS: Only if he abused me. I've only got a right to justice if I'm actually a victim. That's enough questions. I want you to tell me if I was raped or not.

THE PSYCHIATRIST: I told you. It's not as simple as that.

CARLOS: Hypnotise me.

THE PSYCHIATRIST: Hypnosis is a pretty blunt procedure and these days most psychiatrists dispute its therapeutic…

CARLOS: In that case we're done. I could get a psychic to read my cigarette smoke and tell me the truth in five minutes. And she'd charge half what you do.

THE PSYCHIATRIST: …But if you're telling me that it really is a matter of urgency then we could try it. "The customer is always right".

CARLOS: Thank you.

THE PSYCHIATRIST: Whatever happens remember that if we uncover a memory like this you won't be able to carry on living as if nothing happened. It would represent a significant trauma. You'd have to embark on a course of treatment to eradicate any psychological consequences. A long course.

CARLOS: And an expensive one.

THE PSYCHIATRIST: His brother's the manager of the new shopping centre and he doesn't want this one having a go at his arms with a machete again. Everything in life has a price.

CARLOS: OK then. Let's do it.

THE PSYCHIATRIST: It's a wonderful thing, being able to count on your family's support. You have no idea how many people dream of having a brother like yours. A brother to pay your expenses so that you can enjoy the luxury of playing the misfit while the rest of us try just to survive this shit, driving around in second hand crap-heaps and all the time trying to scrape together the money for the Grand Cherokee 4x4 five-speed automatic that I'll never be able to afford, that would shut up the people who think I'm a loser because I spent nine fucking years of my life studying for a job that gives me a wage that's nowhere near enough to secure a loan of ninety million pesos in the first place, and that's not even half what I spent on studying to give myself a better future and be considered by people as someone respectable. Someone. Someone. Just to be someone in this miserable town.

CARLOS: Doctor?

THE PSYCHIATRIST: Sorry. I was thinking.

CARLOS: I haven't got all day.

THE PSYCHIATRIST: Make yourself comfortable and relax. Watch this very carefully. On the count of ten we're going to close our eyes and untangle this terrible thing which is going to cost his brother a treatment as long and expensive as the instalments on a brand new 4x4.

CARLOS: Sorry?

THE PSYCHIATRIST: Close your eyes. You are ten years old. What do you see?

SECOND ACT

SERGIO: Isn't dad in?

THE MOTHER: No.

SERGIO: Carlos?

THE MOTHER: He's at the psychiatrist's. He started back at therapy today. He'll be back on his lithium again, he'll stop telling his fibs, and all this will be over. We can relax. Do you want some? It's valerian. All natural ingredients, no preservatives. I love it, but that doesn't mean I'm feeling nervous, it's just…

SERGIO: It might not all be nonsense this time.

THE MOTHER: People are coming up with all sorts of rubbish to damage your good name. They're dying of envy because you're making a success of yourself while they're starving in their cramped and filthy houses.

Pause.

SERGIO: Did dad tell you anything about…

THE MOTHER: You know what your father's like.

SERGIO: He hasn't told you?

THE MOTHER: Why do we have to talk about absolutely everything?

SERGIO: We're his family. Why didn't he say anything?

THE MOTHER: You sound like a detective in some old film. I don't like it.

SERGIO: Do you think dad could ever have…?

THE MOTHER: Just be careful what questions you're asking. Only the other day I was watching a film about a boy

who believed everything people said and he ended up drowning his father in a trough.

SERGIO: It was on on bank holiday.

THE MOTHER: No. I rented it on DVD. I'm sure I did. I forgot to say: thank you for the DVD player and the washing machine. I don't have to use the old sink outside now. Thank goodness. The tank used to get full of mosquito larvae, and there's no sleeping with mosquitoes around and they're carriers of infectious and contagious diseases such as malaria. So we're better off. Better off with the tank empty, no water, no dead fathers in it, their heads floating up to the surface.

SERGIO: Maybe I saw it on DVD then. My head's all over the place.

THE MOTHER: There's nothing to know. Guess what's for dinner. Tuna salad, your favourite. I listen to another long silence that needn't worry me and it doesn't, on the contrary, I like the peace, the calm. How many families would like to be more like ours? How many families do you see out there squabbling over money, or with a son who's a drug-addict or who's got issues. Carlos's situation is different, you and I understand that, we're at a cultural level where we understand things and accept them… Nobody's perfect after all and that's the lovely thing about our family, we take each other as we are, with all of our strengths and all of our weaknesses. Are you having another one?

SERGIO: It's my first.

THE MOTHER: The first in front of me maybe, I could smell the smoke on him when he arrived. You're working too hard, you should…

THE FATHER: No one's called?

THE MOTHER: No.

SERGIO: Dad…

THE MOTHER: Oh yes, someone did phone but I forgot to write it down, I'm hopeless, I forget everything.

SERGIO: Dad…

THE MOTHER: …Octavio…

THE FATHER: I don't know an Octavio.

SERGIO: I need to talk to you about…

THE MOTHER: …Victor?

THE FATHER: I don't know a Victor.

SERGIO: There's something…

THE MOTHER: Isidro!

THE FATHER: Isidro?

SERGIO: I know you won't like it, but…

THE MOTHER: No. That wasn't it either…

THE FATHER: Then who the hell was it?

SERGIO: But it's important to know what…

THE MOTHER: I don't remember, I think it began with an A…

THE FATHER: Alfredo?

SERGIO: Mum, could you let me speak?!

THE MOTHER: Alberto!

SERGIO: Dad, it doesn't matter who ph…

THE FATHER: I don't know an Alberto!

THE MOTHER: Well Alberto rang.

THE FATHER: Did he say where from?

SERGIO: Could you just stop and liste…

THE MOTHER: No. He said Alberto. Alberto… Or Humberto?

THE FATHER: Can't you even take a simple message?

THE MOTHER: Tania didn't leave one.

SERGIO: Tania phoned?

THE MOTHER: No.

THE FATHER: So what then?

MOTHER: …She came round. But there's no need to look at me like that. I didn't even open the door to her.

TANIA: Tell him I'm not shutting my mouth for less than fifteen million.

THE MOTHER: What are you talking about?

TANIA: Your husband. He tried to fuck my son, did you know that?

THE MOTHER: I don't like to meddle in my husband's private life. We're a modern family. We respect each other's personal space.

TANIA: I thought you might want to know…

THE MOTHER: Well it doesn't interest me and it shouldn't interest you either. Especially if you have absolutely no proof for what you claim happened.

TANIA: It's my son saying it happened, not me.

THE MOTHER: It's a pity you can't prove it, but never mind. Suspicion isn't a sin because it shows some intelligence. Spreading lies about someone, though, is a sign of ignorance and poverty.

TANIA: I'm not ashamed of who I am. I did everything I could to make my son happy. I'm an honourable woman. I've done nothing wrong.

THE MOTHER: You don't look very sure.

TANIA: It's hard being a single mother.

THE MOTHER: I know. Children need a father figure or they can turn out funny.

TANIA: You leave my son alone.

THE MOTHER: Ooh, did I hit a nerve?

TANIA: Fuck off.

THE MOTHER: I don't appreciate people swearing in my house.

TANIA: Your husband's going to have to pay me…

THE MOTHER: I'll give him the message, now please leave. I didn't even open the door to her.

SERGIO: What did she want?

THE FATHER: Don't talk to me like that.

SERGIO: It's just a question.

THE FATHER: How should I know what she wanted?

SERGIO: But…

THE FATHER: And since when do I have to explain myself to you, might I ask? That's the tail wagging the dog, that is.

SERGIO: It's just that…

THE FATHER: I am not going to have this kind of conversation with my children.

SERGIO: Why not?

THE MOTHER: Sergio, please… It's a question of hygiene.

CARLOS: Evening.

THE FATHER: Why do I bother giving you scarves if you never put them on? He's cold, that's why he's always like this.

CARLOS: It's not a cold, dad.

SERGIO: What did Tania say to you, Mum?

THE MOTHER: Have you been crying? Oh no. You're scaring me, sweetheart. And so I whisper, almost in his ear: have you been at the clinic? Did they do a blood test?

CARLOS: I don't have AIDS, mum.

THE MOTHER: Thank God for that.

THE FATHER: What's that?

THE MOTHER: Things a mother says to a son that you wouldn't want to know about.

SERGIO: Dad…

THE FATHER: Bloody therapy! He always comes back in pieces!

SERGIO: Why don't you just have done with it and tell us what the fuck's going on?!

CARLOS: I can't take it any more!

THE FATHER: And he starts sobbing uncontrollably at the table while his mother gives him little pats on the back.

THE MOTHER: Are you alright? Have you got a fish-bone? Oh, I always forget you're a vegetarian. Me and my memory, honestly. I read an article once that said you often forget things that have scarred you in some way. Nightmares, for example, you forget a nightmare in less than three seconds, apparently. I know I do. I know I do. I always forget my nightmares three seconds after I wake up. Do you get that, Sergio?

SERGIO: Mum, be quiet, yeah?

THE FATHER: Get him something…

THE MOTHER: Valerian! I've got some valerian in the cupboard.

THE FATHER: I'll put some water on.

SERGIO: Dad…

THE MOTHER: Listen. It's the CD you gave me. I love this sort of music. When they take songs and make them… more sophisticated.

CARLOS: I'm going to kill myself!

THE FATHER: Right, you're not going back to that psychiatrist. That's it, finished. I mean it.

SERGIO: Why didn't you tell us before we found out from someone else? Do you have any idea what this means for me at work? I've got a whole department looking to me for…

THE FATHER: You might be the manager in your own office, doing what you like, shouting at everyone but in this house I am still your father and you will respect me, is that clear?

SERGIO: I'm not shouting. I'm just saying that we're a family and we should be honest with each other and…

THE MOTHER: Water's boiling…

SERGIO: There's a file on you at the police station. Sexual abuse, dad.

Pause.

SERGIO: I know the case is closed because there wasn't enough evidence and it didn't go any further, but then why didn't you say anything?

Pause.

THE FATHER: You all believe that stupid cow don't you?

Pause.

THE MOTHER: It's quite a long silence, like the ones you get in the films when something important is happening.

SERGIO: Stop thinking, will you? It's not like he can't hear you.

THE FATHER: You hypocrites, you pathetic bunch of traitors.

CARLOS: Oh God.

THE MOTHER: One valerian tea. Oh dear God what are you doing, Carlos? Sergio, grab him!

SERGIO: Calm down. It's the butter knife.

THE FATHER: I've learned not to expect much from Sergio. I never held out much hope for him. But you, Carlos. Do you really think I could do anything to an innocent child by force?

Pause.

THE FATHER: I know you're sensitive, I knew this would hit you hard, that's why I didn't say anything…

Pause.

And I'm ashamed, okay? It's too much for me. I don't… I don't even know how to talk about it. I feel ridiculous trying to explain it… That's all. You do believe me don't you, Carlos?

CARLOS: I stay silent too while I concentrate on trying to cut myself with a butter knife.

THE FATHER: Son of a bitch. The pair of you.

THE MOTHER: Bitch, is it? I'm on your side!

SERGIO: What?

THE FATHER: Get out.

THE MOTHER: You heard your father.

SERGIO: Mum!

THE MOTHER: This is a respectable family, though you two don't seem to think so. Carlos, get your things and go. I'm sick of the sight of you. And Sergio. Is that clear? Don't you pay them any mind, my love, they're young and

confused. Young people get confused very easily. I mean I was confused when I was fifteen and I let myself get pregnant by that idiot, but… well, then I met you, and we got married, and we were happy, and we still are, aren't we, because…

THE FATHER: You believe me don't you? That I haven't done anything wrong?

THE MOTHER: Of course, of course I do, darling, I believe you. If anything like that was true of us then, well, we wouldn't be us, would we. I believe you. I believe you. I believe you. I believe him. I believe him. I believe him. I have to go to bed, I have to go and have my nightmares and then forget them three seconds after I wake up.

SERGIO: If dad had told us in time we could have shut that woman up and that would have been the end of it. What am I going to do now? I get sideways looks every time I go in or out of my office. They all know. Nobody says anything, but I know they all know. Fuck.

CARLOS: I'm sorry.

SERGIO: Stop crying now, yeah? We don't even know if this even happened.

CARLOS: It did happen. I know it did. It happened.

SERGIO: And even if it did, so what? We all know what that woman's like. The whole town knows. The kid must be used to worse than this.

CARLOS: I'm not crying because of Joaquín!

Pause.

SERGIO: What did the shrink say?

CARLOS: He made me remember things. Things I'd forgotten.

Pause.

SERGIO: What, about… dad… and…?

CARLOS: And me... yes.

Pause.

SERGIO: I'm sorry.

CARLOS: I want to die.

Pause.

SERGIO: Alright, but try looking at it from a different angle. This must be a sort of relief for you. It explains so much about your character. Don't you think it's brilliant that the mystery's solved at last? Because I mean now you can be sure it's not your fault you're gay.

CARLOS: Yes... but I don't understand...

SERGIO: I mean, sure, there's a whole process to go through, but you'll keep doing your therapy on it and...

CARLOS: ...how come you like women when you've been through the same thing as me?

SERGIO: What bullshit's this?

CARLOS: It's not bullshit. It's what the hypnosis said. It wasn't just me, dad must have...

Pause.

SERGIO: You bastard lying little poof. You want to make me ill so I'm the same as you. That's what's going on, isn't it? I'm a healthy man, I know I deserve the life I have, the reputation I have, and you know it and the envy is killing you. I'm going to have a child. It's a boy, did I tell you that? A boy. A proper man. And he's going to have a normal life. He's going to go to college, he's going to have girlfriends, he's going to go for women with a good firm arse, pale skin, classy girls, not the dark ones, and he's going to fuck them in the missionary position with a condom, looking them square in the eye when he comes. He's going to know all about business, he's going to earn money, he's going to do a masters abroad, he's going to

respect authority, he's going to hate terrorism, he's going to buy a house in the north and he's going to have children who'll go to bilingual schools where they'll be surrounded by trauma-free classmates, baptized as Catholics, vaccinated against chickenpox, the flu and hepatitis B and with American visas so they can go on holiday to Miami. Kids who'll lead expeditions with the Scouts, put clean white shirts on to protest against kidnappings and when they grow up they'll discretely pay for private security for grandpa Sergio so they can visit him on his farm every Sunday in peace, in safety, in their brand new cars to thank me for the future I've given them and the disasters I've spared them by giving them a good name, good blood, good genes, a good reputation, a safe country, a fair country, one that works. We're not the same, Carlos. I'm not ill. If you ever suggest that again I'll give you such a kicking, like in the good old days. And if you have to cry keep it down. My wife's asleep.

THE PSYCHIATRIST: I'm bound by a code of professional ethics. My patients' information is completely confidential.

SERGIO: I don't want to know when Carlos had his first wet dream over Brad Pitt. Just tell me what you know about me.

THE PSYCHIATRIST: You are the manager of the shopping centre, your wife is expecting…

SERGIO: I mean about my father and me.

THE PSYCHIATRIST: Therapy is a long and far-reaching process. We have to start by analyzing the psychodynamic structure of what you're saying here. This is just the tip of the iceberg.

SERGIO: I'm prepared to meet you halfway if it means we can get things moving and sort this thing out.

THE PSYCHIATRIST: You'd have to start a course of treatment.

SERGIO: OK.

THE PSYCHIATRIST: Sessions are payable in advance.

SERGIO: Who do I make the cheque out to?

THE PSYCHIATRIST: You're making me feel like some kind of psychiatric mercenary.

SERGIO: Does that matter?

THE PSYCHIATRIST: No. Manuel Sepúlveda.

SERGIO: I'll pay you for five sessions up front.

THE PSYCHIATRIST: Eight.

SERGIO: Six.

THE PSYCHIATRIST: Seven, it's my last word. Cheques go to my secretary. Money isn't really my thing. If it was I'd be in sales for some big-pharma multinational and get a loan to buy a car like the one he's been parading up and down the Avenida Bolívar in just as everyone's coming out of work trying to make us all feel insignificant in our second-hand bangers.

SERGIO: Sorry?

THE PSYCHIATRIST: Nothing. What is it you want to know?

SERGIO: I assume it must be obvious to you that my brother… may have suffered some kind of abuse when he was a boy.

THE PSYCHIATRIST: Well…

SERGIO: You don't have to respond. I know you have your code of ethics. Just tell me if anything he said under hypnosis concerns… me in particular. You know what I'm talking about, don't you?

THE PSYCHIATRIST: Of course I do. It's your twelfth birthday. You're sitting by the river. You're crying. Your brother is watching you. Just before that he saw you coming out of the tent adjusting your sweatshirt. Just before that he hears your dad telling you that there are secrets that have to stay secrets. Just before that he sees your dad coming

out of the tent wiping himself with a piece of tissue. Just before that he sees him touching the scar on your leg and whispering the word 'gorgeous'. Just before that your dad is telling you not to look, to count the pebbles that you still like collecting even now and you did what he told you but out of the corner of your eye you could just see his hand in a fist moving up and down, faster and faster. One. Two. Three…

SERGIO: I don't believe you.

THE PSYCHIATRIST: Your brother seems to remember it all very clearly.

SERGIO: The description's too precise to be credible. Carlos is gay and he wants to pin all the shit that made him that way on me. He knows nothing about anything and neither do you.

THE PSYCHIATRIST: You got the scar on your leg when you were playing in a guava tree aged seven. You bought the sweatshirt in a sale at the same time as some trainers that you never wore because they were too small. The tent was a gift from an aunt who lives in Spain who can't have children. You still keep the stones in a box in the attic where your father used to lock you all day every time you beat up your brother because you couldn't stand him being so effeminate.

SERGIO: If it was true I'd remember it but I don't remember any of it.

THE PSYCHIATRIST: Sometimes it's healthy for us to forget.

SERGIO: Carlos is a fantasist. He invents things.

THE PSYCHIATRIST: Not under hypnosis he doesn't.

SERGIO: Why are you enjoying this so much?

THE PSYCHIATRIST: I love my job.

SERGIO: My dad can't have done that to me.

THE PSYCHIATRIST: He's not your dad though is he…

SERGIO: Shut up…

THE PSYCHIATRIST: It's not a secret, everyone…

SERGIO: Just shut the fuck up!

Long pause.

SERGIO: He is my father.

Pause.

SERGIO: He raised me.

Pause.

SERGIO: He gave me his name.

THE PSYCHIATRIST: But you don't have his genes, that's all I'm saying.

SERGIO: And he hates me for it.

THE PSYCHIATRIST: And nothing you ever do will be enough for him. Not even managing the town's first shopping centre or having a pregnant wife, with the blessing of the Catholic Church.

SERGIO: It was revenge. He was getting his revenge on mum through me.

THE PSYCHIATRIST: It's what's known as catharsis.

SERGIO: Can I smoke?

THE PSYCHIATRIST: Smoking seriously harms you and others around you. But go ahead. "The customer is always right." What's this? A tip?

SERGIO: No one finds out I came to see you.

THE PSYCHIATRIST: I am of course bound by my professional code of ethics. But thanks anyway.

SERGIO: Thank you.

THE PSYCHIATRIST: I'm glad I could help. Very glad. See you again, I hope.

SERGIO: Carlos, I don't hate you for being my brother.

CARLOS: Sergio, I don't hate you for getting better grades than me.

SERGIO: I don't hate you for doing it with men.

CARLOS: I don't hate you for being a father-to-be.

SERGIO: I don't hate you for not envying me.

CARLOS: I don't hate you for tearing up my porn.

SERGIO: I don't hate you for being effeminate.

CARLOS: I don't hate you for being ashamed of me.

SERGIO: I don't hate you for not voting.

CARLOS: I don't hate you for voting Uribe.

SERGIO: I don't hate you for being a vegetarian.

CARLOS: I don't hate you for having money.

SERGIO: I don't hate you for being bipolar.

CARLOS: I don't hate you for not being dad's son.

CARLOS and SERGIO: I don't hate you for hating dad.

CARLOS: So?

SERGIO: What?

CARLOS: We can't leave it like this.

SERGIO: Look, we're not doing anything.

CARLOS: But…

SERGIO: I've got a job…

CARLOS: But…

SERGIO: A wife.

CARLOS: But…

SERGIO: And soon I'll have a son. I'm going to chew up all my anger and swallow it bit by bit until I get used to it living inside me. You do the same. Nobody can know anything about this.

CARLOS: Not about us, no… but the Tania thing… people know about that anyway.

SERGIO: There's a long silence while I listen to what he's thinking…

CARLOS: …that all we need for justice to be done is a good pretext: a kid from a poor family, abused by his mum's boss. He looks at me.

SERGIO: I look at him….

CARLOS: He's not going to admit I'm right.

SERGIO: I'm not going to admit he's right.

CARLOS: But he knows I am. And he'll do something about it. I'll sleep better now.

SERGIO: What does it matter? The guy's not my father anyway.

TANIA: If you've come to threaten me, watch out: I've got a Doberman cross that's not even had his rabies jab out in the yard and on Joaquín's birthday it bit him on the arse. I wish it'd taken a bigger chunk out of it. Toughen him up. Make him less appealing to depraved eyes.

SERGIO: That's not why I'm here. I'm from the sort of family where morals come first.

TANIA: Before my son, even.

SERGIO: Before my loyalty to dad.

TANIA: Total bullshit.

SERGIO: I'm going to pay for you to have the best lawyer there is and he's going to make sure that man pays for what he did to your son. I was volunteering in the Red Cross when I was twelve. I like things to be fair and I care passionately about social inequalites.

TANIA: Such a good person. What do you want me to do? Get down on my knees? Pay the priest to say a mass for you? Suck your cock?

SERGIO: I'm grateful to you for having brought all this to our attention. Why don't I lend a hand. I know that you and your son are going through a lot as a result of an injustice that could be very expensive to prove if you use an ordinary lawyer.

TANIA: There's no proof and you know it. Look, are you just here to take the piss?

SERGIO: No. There are lawyers who can cut through all the red tape and get this case to court on your son's testimony alone.

TANIA: I don't have that kind of money.

SERGIO: I know. And it doesn't matter. I like to give something back.

TANIA: Oh please.

SERGIO: I'm being serious. Just one thing: don't tell anyone I'm behind this. I give you the money, you pay the lawyer, just pretend the money is yours, and we all get to enjoy the justice, the peace and the reputation we deserve.

THIRD ACT

THE MOTHER: There's no standards any more. The most respected lawyer in town and even he's turned into a leech.

CARLOS: Who has?

THE MOTHER: Prieto. The best lawyer in this stupid town and he's taken on Tania's case. He's taking your dad to court. Where's your father going to get a lawyer to match him?

CARLOS: Don't know.

THE MOTHER: I just don't understand where that witch could have got the money from.

CARLOS: Savings.

THE MOTHER: What savings could that woman have?

CARLOS: Don't know.

THE MOTHER: Is that all you can say?

CARLOS: Is he going to prison?

THE MOTHER: How can you even think such a thing?

CARLOS: So what's the problem?

THE MOTHER: The boy's goes to the child psychiatrist next week. And then whatever he says gets reported back to the court. They're going to use it as evidence.

CARLOS: And?

THE MOTHER: That bloody leech is forcing a poor peasant boy, a victim of violence, to come out with these terrible things and it's not right. If we had any money we'd hire the best lawyer we could to put a stop to it, but we don't, I sold the DVD, mum's necklace, I cancelled the internet, but it's not enough, and your father refuses to sell that stupid farm.

CARLOS: What about Sergio?

THE MOTHER: He says he hasn't got any money, and he's not even helping with the mortgage any more. I've got a nasty feeling I know why that is but I'd rather think it and not say it.

CARLOS: I've got to go to work.

THE MOTHER: Talk to him. You two are much closer now you're living at his.

CARLOS: If he says he hasn't got the money…

THE MOTHER: Of course he has. He's the only one who can help us. Imagine if your father ended up in prison because he couldn't afford to defend himself against this awful, awful slander.

CARLOS: I'm not going to talk to Sergio, mum. Forget it.

THE MOTHER: We must have done something wrong. That's all I can think. It's as if we're being punished for something. God has forgotten us.

CARLOS: You haven't been to church in years.

THE MOTHER: That's because I'm a modern woman, not because I've lost my faith. And don't you laugh, this is serious.

CARLOS: If he's innocent there's nothing to be afraid of.

THE MOTHER: We can't all be like you. We can't all lead our lives as if we're going to come back as a sacred cow. What's the point of being innocent if everyone thinks you're not?

CARLOS: Innocent?

THE MOTHER: This is your father we're talking about, in case you'd forgotten.

CARLOS: I haven't forgotten.

THE MOTHER: Well then?

Pause.

CARLOS: I haven't forgotten.

THE MOTHER: So that snotty child can say what he likes, can he? And your father will be found guilty and taken to prison, and we'll visit him every Sunday and the neighbours will carry on whispering and giving me sideways looks and crossing the road to avoid me and throwing rotten eggs at our door and not letting their kids play on our block and pretending not to see me when I pluck up courage to go and say hello because they think I'm a pathetic loser, a Protestant, a pimp, a paedophile, and poor?

CARLOS: Count yourself lucky. What about Sergio and me? You ended up with dad because you chose him. That wasn't an option for us. If anything you're a victim of your own ignorance.

THE MOTHER: I don't know what you're talking about.

CARLOS: Yes you do. You know, you must have an inkling.

THE MOTHER: No I didn't, I don't know anything about it, and do you know what, Carlos, I'm not interested. Why don't you use your feminine sensitivity for something other than staring at naked men on the internet and put yourself in his shoes for a moment? Tell Sergio it's a matter of life and death.

CARLOS: I don't even like pornography!

THE MOTHER: I only had you because he hid my pills. You owe your life to him, not me.

CARLOS: You monster. You're both monsters.

THE MOTHER: Your father is innocent.

CARLOS: Where did she read that? I thought they'd had the internet cut off.

THE MOTHER: I could still give you a good smack for talking to me like that.

CARLOS: I'm not talking.

THE MOTHER: I can hear you though.

CARLOS: You don't believe him either.

THE MOTHER: Life is just a matter of faith.

CARLOS: Life is just a heap of shit.

THE MOTHER: I thought you were seeing the psychiatrist again.

CARLOS: I thought you loved me.

THE MOTHER: I'm your mother. A mother loves her sons. It's instinctive. What's all that therapy for if they can't even get that in your head?

CARLOS: Shall I tell you what it's for?

THE MOTHER: No.

CARLOS: You'll have to give me a good smack then…

THE MOTHER: That's enough.

CARLOS: …a little reminder of what dad used to do, to me and Sergio, when we'd go for walks down by the river and…

THE MOTHER: Don't even think about coming home.

CARLOS: You've thrown me out.

THE MOTHER: There's blood coming from the corner of his mouth and I think: I should have listened to my mother. I think I should have had my tubes tied.

CARLOS: Yes, you should.

THE MOTHER: It's dangerous to leave children alone in the house.

JOAQUÍN: What shall I say to mum when she comes back?

THE MOTHER: Nothing. It's you I want to talk to.

JOAQUÍN: But I'm locked in.

THE MOTHER: A while ago I read an article about a boy who burned to death because his parents left him locked indoors. Lean out a bit further.

JOAQUÍN: There are people watching.

THE MOTHER: I know. They're eating us alive in this bloody town. I can't leave the house. I can't go online. I can't watch films. I can't shout because everyone on the whole fucking block would hear me. You can still change your mind.

Pause.

JOAQUÍN: About what?

THE MOTHER: You know.

Pause.

THE MOTHER: Do you know how much weight my husband has lost in the last few months? He doesn't go jogging any more, he doesn't swim in the river, he's stopped going for walks. He's such a good man, such a nature-lover. You know that, don't you?

JOAQUÍN: Yes.

THE MOTHER: Well then?

Pause.

THE MOTHER: He told me to give you this. He said your reading's good enough now.

JOAQUÍN: Thank you.

THE MOTHER: He said he'd promised to get it for you, and a promise is a promise. Even though you said all those bad things about him to your mummy, a promise is still a promise.

JOAQUÍN: What else did he say?

THE MOTHER: That he doesn't hate you.

JOAQUÍN: I don't hate him either.

THE MOTHER: You see? It doesn't have to come to this.

JOAQUÍN: My mum says that justice has to be done.

THE MOTHER: Your mum doesn't know it never happened. You do.

Pause.

JOAQUÍN: It did happen.

THE MOTHER: If you're telling the truth, how come you're so sad?

JOAQUÍN: Don't know.

THE MOTHER: Do you know how long my husband would spend in prison if they say he's guilty? His whole life. Do you know how long a whole life is, Joaquín?

JOAQUÍN: I'm only twelve.

THE MOTHER: Thirteen. You'll be thirteen next month. My husband remembered. He wanted to throw you a party with cake, and a big piñata.

JOAQUÍN: I'm not a baby.

THE MOTHER: He was going to give you the mobile phone you wanted for Christmas. But he won't be able to if this carries on.

Pause.

THE MOTHER: My husband is an old man. He's sixty, he's got high blood-pressure, and for two months all he's done is sit in the house crying, with all those ignorant people thinking the worst of him. Have you ever been inside a prison? Do you know what they're like?

JOAQUÍN: I'm not allowed to visit my uncle.

THE MOTHER: It's hell.

JOAQUÍN: Hell doesn't exist.

THE MOTHER: They take the prisoners and they torture them. I bet you like horror films, don't you.

JOAQUÍN: Yes.

THE MOTHER: Well prison is worse than the worst horror film. They hurt people. They cut their tongues out and they pull their willies off. I like your t-shirt.

JOAQUÍN: It's got a stain on the back. Plantain.

THE MOTHER: Do you know how much those cost in town?

JOAQUÍN: Don José says you shouldn't ask the price of things you get as presents.

THE MOTHER: That's because he's very generous.

JOAQUÍN: But he didn't want to see me any more. That's why he threw mum off the farm.

THE MOTHER: He threw you off the farm because your mummy was letting all the plantains rot. She was making everything go bad. So of course she ended up without a job. And now she wants to get her own back. What can we do? If we could afford to pay her to do the cleaning once a week we would, of course we would. But we can't. We're almost like poor people now, that's what your mother doesn't understand. That's why she's trying to get her own back. Do you know how much money is being spent because of you?

JOAQUÍN: You've got loads.

THE MOTHER: Not any more we haven't.

JOAQUÍN: Don José treated me badly. He said horrible things to me. Things that hurt.

THE MOTHER: You have to learn to forgive.

JOAQUÍN: I have to…

THE MOTHER: You have to be quiet. Just be quiet. It wouldn't surprise me if he'd been putting up with this for years, so why is he piping up now? Does he think it'll stop his mother beating him or being sorry her son's a poof? He's such a good man, why are you trying to make him hate you? He can make sure you don't end up like your mum.

JOAQUÍN: I don't want don José to hate me.

THE MOTHER: Well he will if you carry on like this.

JOAQUÍN: I've got jobs to do. Here.

THE MOTHER: But you can read this bloody book can you? And write? Thanks to who?

JOAQUÍN: Don José is a bad person.

THE MOTHER: As a matter of fact he is. Very bad. If you talk he's going to come and do what he tried to do before. He's going to grab you by your bits, and then he's going to put his cock up your arse and believe me that hurts.

JOAQUÍN: Let go!

THE MOTHER: The good thing about being poor is that you've got nothing to lose. That's how this lot get away with spending their whole lives making up stories to ruin us and laughing in our faces. I bet you wish you'd come from me instead of mummy, don't you?

JOAQUÍN: No.

THE MOTHER: I bet you wish you'd been my José's son, don't you, not some useless drunk's you've never even met.

JOAQUÍN: No.

THE MOTHER: If you had more sense you might even be able to get him to pay for your secondary school. And university. Graduate, buy a Grand Cherokee automatic,

get your wife pregnant with the blessing of the Catholic Church, manage a shopping centre and pay your mother's mortgage for her…

JOAQUÍN: I don't like studying. I don't like cars. I'm not baptized. I don't like being in charge of things. And it's a rented house.

THE MOTHER: You're not baptized?

JOAQUÍN: Mummy's a Jehovah's Witness.

THE MOTHER: That's why he lives like an animal.

JOAQUÍN: The football got left at the farm.

THE PSYCHIATRIST: Go on.

Pause.

THE PSYCHIATRIST: Joaquín?

JOAQUÍN: Yes?

THE PSYCHIATRIST: You can go on.

Pause.

THE PSYCHIATRIST: No one will know we're having this chat. It'll be our secret.

JOAQUÍN: The football got left at the farm after we moved. Everything was such a mess I didn't notice for a week. It was a present from Jesus and I didn't want it to get lost. So I went there and said hello to don José, I asked him if I could go and see if it was round by the machine that does the coffee beans because that was where I used to like to go and play. He let me in to have a look and I found it stuck behind the machine. I bent down to get it out and I got the knees of my trousers dirty. They were my Sunday trousers. I'm not allowed to get them dirty. I went to the trough, put a bit of water on them and started scrubbing them. Don José said he'd help. He came up and helped me with the soap, and then he put some water on my trousers.

I told him to be careful because I couldn't get them too wet otherwise mum would realize I'd got them dirty. Then he stopped and he was looking at me, he took off his trousers and his pants, and then his shirt. He was in the nude. His thing was pointing up straight and it was frightening. I didn't know it could grow so much and go all red. I was embarrassed and I went red too. He grabbed my hand and told me to be a good boy because if I wasn't he'd hit me. I got scared. He made me touch it and it was hard. I didn't know it went like that. It frightened me and I let go of it and just as I was about to scream he put his hand over my mouth. But I got away, and I started crying and then I ran away through the plantains and I got to the road and a jeep came past and took me to the village. Then I got home and I told my mum everything because it's true. It's all true. I'm not a liar. I don't like telling lies. Mum said it was his cock and she told me why it gets so big and hot when people touch it. He didn't catch me because he had his trousers round his ankles. He wasn't in the nude. I can't really remember. But it's true because I don't tell lies. My mum says that when we leave here she's going to take a photo of me going up the escalators at the shopping centre and then she's going to buy me a mobile phone with a camera and a Paulina Rubio ringtone as a reward for being so brave. But I don't know if sending a man to prison should get a reward. His wife told me he was really sad and couldn't stop crying. But mum says that's a lie because bad people don't cry. So that must mean I'm a good person because I cry and cry because I feel sorry for don José because… because… he didn't do anything and I lied, but I'm still a good person because I'm crying because I didn't believe that everything would get so complicated and I want to go home and I don't want to talk any more but I'm talking and I'm shaking. My eyes are burning and my nose is full of snot and I keep saying stupid stuff I learned by heart, stuff mum said I should tell them so I'd get my own camera-phone and ring whoever I like and take pictures. But I'm twelve and I don't know what's wrong with me, I

don't know what to say. I don't know why I said it. I don't know. It doesn't really matter. Paulina Rubio's not cool any more anyway.

THE PSYCHIATRIST: That's all. Thank you.

TANIA: I'm sure he fucked him. More than once. I'm certain he did.

THE PSYCHIATRIST: You should be ashamed, putting your son through a sham like this.

TANIA: He's just a boy. He got scared and started talking rubbish, but I'm not. I'm telling the truth. "He that speaks the truth shows forth righteousness".

THE PSYCHIATRIST: Señora, I have patients waiting outside…

TANIA: That bastard's wife went to my house to threaten him, she said she'd break his bones and burn him alive if he told the truth. She even scratched his face, she almost blinded him.

THE PSYCHIATRIST: The boy didn't tell me that.

TANIA: Well he's afraid, isn't he! Even that bastard's family think he did it. Don Sergio paid the best lawyer in town for me to get the case re-opened, did you know that?

THE PSYCHIATRIST: Revenge is a very human instinct.

TANIA: I can pay you.

THE PSYCHIATRIST: How much?

TANIA: A hundred thousand pesos.

THE PSYCHIATRIST: That doesn't even cover one session. Who do you think I am?

TANIA: I could work for you. For free. Clean your house, the surgery.

THE PSYCHIATRIST: The report's been submitted. I'm not changing it.

TANIA: I'm begging you. Have some pity for God's sake. I can't live like this. Someone's got to pay for this guilt, it's weighing on me, it's burning me like iodine on an open wound. Doctor, I'm drowning inside. I can't breathe. Look. See that? I did that to myself. With rose stems. I leave them to soak in the trough every night. Because it's my fault too and I'll go to hell, because I know hell exists even if the pastor says it doesn't, I'm not stupid. But punishing myself isn't enough. That bastard has to pay for what he did to my son. Ask him again, for Christ's sake!

THE PSYCHIATRIST: I'm going to give you some advice, for free. Neither you, nor that man, nor anyone else is to blame for the fact that your son is going to be gay. Accept him for who he is and move on.

TANIA: I'd rather kill him.

THE PSYCHIATRIST: Goodbye.

Short pause.

TANIA: Did you know that I can suck you off and lick your balls at the same time? Has anyone ever done that to you? He's looking at me like he doesn't believe me but would love to have me try, because let's face it we've all had to learn a thing or two to keep us from starving, and we all have needs.

THE PSYCHIATRIST: I don't have as many as you. At the weekends I pay for whatever fantasy I like. A mulatta who sweats a lot blindfolds me and makes me come just by rubbing me between her two unbelievably firm, surgical tits. Leave now or I'm calling security.

A long pause.

THE PSYCHIATRIST: Did you not hear me?

Pause.

THE PSYCHIATRIST: Tania?

TANIA: I knew the boss liked looking at him… and I knew it was a good idea to keep the boss happy. What did it matter if he was looking or not, as long as the boy didn't realize and he kept giving me money to buy him clothes, it's so expensive, all that stuff. I'm a mother. I have to think of everything.

THE PSYCHIATRIST: Don't give me that. You brought it on yourself.

TANIA: Looking is one thing, touching is something else. Temptation is different to sin.

THE PSYCHIATRIST: Señora…

TANIA: I never thought the bastard would go that far, that's why I let him look, if I'd known he'd done something more I'd have put a stop to it straight away, I swear. I'm not a bad mother. I'm not a bad person. I'm not a bad mother, I'm not a bad per…

THE PSYCHIATRIST: What could you have done. You're a retired prostitute.

TANIA: Fuck you!

THE PSYCHIATRIST: Welcome. It must have taken a lot of courage to go out in public again, after what you've been through. Come in.

THE FATHER: Yes, I can still feel people's eyes on my back like flies round rubbish, but I'm not going to give anyone the pleasure of admitting it. I take a step forwards pretending to be perfectly at ease, as if I hadn't heard what he said…

THE PSYCHIATRIST: You don't have to think out loud any more. We're a modern city, we have a shopping centre full of people buying Christmas presents for dysfunctional families. We've grown, we respect each other's private lives now.

THE FATHER: I don't. I'm from the country and if I can't think out loud I'll explode.

THE PSYCHIATRIST: Unless you engage the services of a professional to listen to your confessions in private. Have a seat.

THE FATHER: That's not why I'm here. I don't believe in therapy.

THE PSYCHIATRIST: You will do.

THE FATHER: I'm just here to thank you for being the only person in this whole bloody town who knows the truth when he sees it. So thank you.

THE PSYCHIATRIST: No, thank you. Thanks to your case paranoia is suddenly all the rage here. We're making progress every day, we're leaving the dark of the parochial church behind and moving into the bright lights of the city and science and the questions that bury themselves like needles in the brains of mothers driven by paranoia to find out who touched up their kids. Of course the past can be made to explain anything. And science is a very flexible tool. Doubt is the key. So thank you.

THE FATHER: That's all I wanted to say. Goodbye.

THE PSYCHIATRIST: I can offer you a complimentary diagnosis, no commitment.

THE FATHER: I'm not interested.

THE PSYCHIATRIST: One naïve child tells a lie and look what happens. It can't have been easy, having no one around you who believes in your innocence.

THE FATHER: I told you. I'm not…

THE PSYCHIATRIST: And with your eldest son paying for a lawyer for the woman who accused you...

THE FATHER: What?

THE PSYCHIATRIST: You didn't know?

THE FATHER: Why would Sergio do something like that?

THE PSYCHIATRIST: The workings of the unconscious mind are complex. Paranoia is very much an illness of our times. Nobody believes in anything. Nobody trusts in anyone. Not even their own parents.

THE FATHER: What are you trying to say?

THE PSYCHIATRIST: I'm sorry. I'm not allowed to disclose details of my patients' cases.

THE FATHER: What are you trying to say? That Sergio thinks I could have…?

THE PSYCHIATRIST: Well, we'd have to start by analyzing the psychodynamic structure of what you want to know. Therapy is a long and far-reaching process. Long, above all. This is just the tip of the iceberg.

THE FATHER: Just answer the question will you.

THE PSYCHIATRIST: Ask my secretary for an appointment. I've given you too much of my time already, I have patients waiting outside and I have to leave early to show off my brand new car by the entrance to the newly-opened shopping centre. Thank you for coming, and we'll see you again.

SERGIO: Tuna salad?

THE MOTHER: Your favourite. His favourite. I made it specially with you all in mind. Well, nearly all of you. But before we start I wanted to say a quick Christmas toast because here we all are, the whole family round the table again…

CARLOS: Like all those Decembers we pretend that we miss.

THE MOTHER: Carlos, people like us don't think out loud any more.

SERGIO: Cheers!

CARLOS: Cheers!

SERGIO: More wine, dad?

CARLOS: Ah, here's the natilla and the buñuelos…

SERGIO: My baby's due in two weeks. We're going to call him José. It's a boy, like you wanted, dad.

CARLOS: I did the nativity scene myself. It looks like real moss, doesn't it, but it's acrylic or something because we have to protect nature, just like you taught me, dad… thank you. Thank you for always thinking of me. Thank you for being the father you are. Thank you for preferring me to him. Thank you for teaching me to love the countryside and hate the city. Thank you for not having done anything bad to me when I was a boy. Thank you for understanding that I'm a bipolar compulsive fantasist. Thank you.

SERGIO: Thank you for not inviting my wife. Thank you for always being disappointed in me. Thank you for not preferring me to him. Thank you for making me fight for your approval. Thank you for not giving it to me. Thank you for not touching me up. Thank you for giving me the family name. Thank you for not loving me as much as Carlos. Thank you.

CARLOS: Thank you.

SERGIO: Thank you.

CARLOS: Thank you.

SERGIO: Thank you.

THE FATHER: Sergio, you paid for Tania's lawyer.

Short pause.

SERGIO: What… are you talking about, dad?

THE MOTHER: Shall we start with a little prayer?… In the name of the Father, the Son and the Holy Spirit, amen… "Blessed Lord of infinite grace, who so loved man…"

THE FATHER: What did you think Joaquín was going to say to the shrink?

THE MOTHER: "…that you gave your only son as the greatest token of your love…"

SERGIO: I never paid for her lawyer.

THE MOTHER: "… so that, made flesh in the womb of a virgin, he might be born in a manger for our salvation and redemption."

SERGIO: I would never…

THE MOTHER: "Let us give you infinite thanks for such sovereign grace…"

THE FATHER: Don't give me your lies. I might have known you'd be capable of something like this.

THE MOTHER: "… and in return I offer you…"

CARLOS: Sergio… How could you do something like that? I swear, dad, if I'd known… I'd have told you, I'd have done something to stop him…

THE FATHER: I know you would.

SERGIO: You'd have done something to stop me?

CARLOS: Of course I would.

THE FATHER: Tell your brother to leave. I don't want to spend Christmas with him.

CARLOS: Sergio, you…

SERGIO: I thought we were together on this, Carlos.

CARLOS: I don't know what you're talking about.

SERGIO: It was your idea.

CARLOS: That's not true. Don't believe him, dad…

SERGIO: It was Carlos who said that Tania…

THE FATHER: It doesn't matter what Carlos said, he's a fantasist. What matters is that you thought I did it...

SERGIO: Oh come on, dad, it's obvious it was all dreamed up by the boy and…

THE FATHER: I'm not talking about Joaquín, I'm talking about you, you thought I was capable of crossing the line with you when you were a boy, didn't you? And you still do, you little shit!

SERGIO: No.

THE FATHER: Say that to my face.

SERGIO: No!

THE FATHER: Fuck's sake, look me in the eye and say it.

Pause.

THE FATHER: Say it, you little fucker!

Pause.

THE FATHER: I should never have given him my name.

SERGIO: You never loved me. I was always just a nuisance. An embarrassment.

THE FATHER: And you still are. It'd make me feel sick, touching you.

SERGIO: It would now, but when I was a boy, when we used to go camping by the river…

THE MOTHER: Sergio, in God's name!

SERGIO: You wouldn't have done it if you'd been my real father, would you?

CARLOS: How can you say that to my dad?

SERGIO: Oh shut up you little queer.

THE FATHER: Don't you talk to my son like that. You are a guest in this house and you always have been.

SERGIO: At least I'm not a hysterical queen who takes it up the arse from his boss at the grill.

THE MOTHER: That's enough.

SERGIO: It's true. Everyone knows it.

THE FATHER: Carlos… is this true?

Pause.

THE MOTHER: Who'd like to give me a hand with the plates?

Pause.

FATHER: Answer me.

Pause.

CARLOS: They don't pay me enough. And the tips are for the waiters. You can't do anything on that money. I have to get by somehow. And if it's any consolation it's Edgar who's in love with me not the other way round. That makes me less gay. And he's helped me appreciate the importance of practical decisions.

SERGIO: Like eating meat.

CARLOS: I wasn't getting all my nutrients.

Pause.

THE FATHER: I told you you were spoiling him and now look. Happy now? I hope you're proud of yourself.

THE MOTHER: Do you think I didn't try to avoid this? Do you think I'm enjoying this?

THE FATHER: I expected better of you… I thought we understood each other, you and me. I thought I'd set you a better example.

CARLOS: It's not my fault…

THE FATHER: Whose is it then, for fuck's sake?

CARLOS: Well, it's…

THE FATHER: Stop crying and talk like a man.

CARLOS: It's yours.

THE FATHER: What?

CARLOS: It's your fault. You made me this way. You made me gay. I was just a boy, I couldn't decide for myself, you forced me, Sergio and me. I remember it all, every little detail, and so does Sergio. The river. The pebbles. Coming out of the tent, sssh, keep it all a secret, the tissue, everything…

THE MOTHER: Shut up. You and Sergio and Tania all working against your father with your dirty hands and now you come here to get them clean. Because they're filthy, and you know it…

CARLOS: It's the truth, mum.

THE MOTHER: I've raised a pair of wolves, that's the truth of it.

CARLOS: You never did anything, mum… you knew what he was up to and you never did anything.

THE MOTHER: Carlos, you sound like a bad soap opera, stop it.

CARLOS: You knew, didn't you. I can see it in your eyes. You knew. That's what all the cancer was about, wasn't it? The guilt had to come out somehow…

THE MOTHER: How dare you…

SERGIO: Why do you still believe him, mum, when you know what he's done?

THE MOTHER: Well of course I believe him, he's my…

SERGIO: That's what the nightmares are about…

THE MOTHER: I don't even remember them…

SERGIO: Of course you do. You remember everything.

THE MOTHER: You ungrateful little bastard. I put up with a man who failed to give me a single orgasm in thirty years of marriage just so that you would have a father!

CARLOS: Mum, how could you have…

THE MOTHER: And you can shut up, you little queer. If your father did things to you when you were a boy it'll be because you deserved it.

Pause.

THE MOTHER: I'm sorry, sweetheart… I get very upset when I see injustice. There. All better now. Isn't anybody going to eat anything? There's lots more natilla in the fridge if anyone wants to have…

THE FATHER: You're defending me even though you think I'm guilty…

THE MOTHER: Love conquers all. Whatever happened, I forgive you. Don't worry, we won't ever talk about it again. I thought I told you two. Go on, get out.

THE FATHER: No. I'm going.

THE MOTHER: Darling, you haven't eaten a bite.

THE FATHER: You sicken me. All of you.

THE MOTHER: I don't deserve to be spoken to like that. I've defended you when the whole world was against you. You know I have.

THE FATHER: I'm going back to the farm. I should never have left it.

Long pause.

THE MOTHER: Well good. Go on then. What use is a husband who's practically impotent? If my prosthesis bothered you

that much you should have paid for me to have plastic surgery instead of refusing to touch me for two years. And if bringing up someone else's child wounded your pride you should have asked me for a divorce. I'm the one who's suffered here. Let him go. I coped with cancer, I'll cope with this, won't I… The other day I was watching a film about… about…

THE FATHER: It was your tenth birthday, Carlos. You and your brother were having a swimming race and you'd lost, again. Sergio was making fun of you, so you hid in the tent because you didn't want him to see you crying. I came in, and I gave you a tissue to blow your nose. You told me not to say anything. Some secrets have to stay secret, dad. I said OK, let's help you get your own back, so we took Sergio's pebbles and we counted them out, one two three, and hid them in his shoes so he'd stub his toe on them when he put them on. And it worked. And you and I had a good laugh about it. Different times.

The Father goes.

Pause.

CARLOS: Don't look at me like that. It's not my fault. I'm a compulsive fantasist.

MOTHER: Get out. The pair of you.

EPILOGUE

THE FATHER: Go away. I don't want to see you.

JOAQUÍN: You haven't been back to the village much.

Pause.

You've done the farm up really nicely don José.

Pause.

Thanks for the book. I've almost finished it.

THE FATHER: What book?

JOAQUÍN: The one you… Doesn't matter…

THE FATHER: Just go away will you?

JOAQUÍN: Cool swing. Can I have a go?

Short pause.

I was angry because of what you said that time and I wanted to get my own back. I didn't think there'd be all this.

THE FATHER: What do you want? Do you want someone to see us? Do you want the whole thing opened up again, with you saying I fucked you to get you back for the lies you told?

JOAQUÍN: But there's nobody here.

THE FATHER: No. There isn't. I live on my own now. I don't like people visiting and I don't like towns.

JOAQUÍN: You're not going to prison any more, are you?

THE FATHER: No. Alright, down you get. Oh my God…

JOAQUÍN: What?

THE FATHER: Your legs…

JOAQUÍN: She got me on the back too. Look…

THE FATHER: There's no need. That's enough. Put your shirt on please, Joaquín.

JOAQUÍN: But I remembered what you told me, José. I looked her right in the eyes and I held back the tears until she was too ashamed to carry on and she fell down on the ground and started crying.

THE FATHER: She'll kill you if she finds you here.

JOAQUÍN: She thinks I'm at Sunday school.

Pause.

JOAQUÍN: I brought my machete in case you wanted some weeding doing…

THE FATHER: I told you, Joaquín. That's it. That's it. That's it.

JOAQUÍN: Why?

THE FATHER: You really don't know?

JOAQUÍN: I won't do it again. I swear. I won't tell any more lies. I'm sorry.

THE FATHER: I got rid of your mum because I didn't want to see you any more. Why can't you understand that?

JOAQUÍN: But you can't look after the farm on your own.

THE FATHER: I've taken someone on.

JOAQUÍN: Who?

THE FATHER: Go away Joaquín.

JOAQUÍN: Can I come and visit, don José?

THE FATHER: No.

JOAQUÍN: I'll tell the doctor it was all true, then.

THE FATHER: What? All that rubbish about dirty knees and me grabbing you at the trough?

JOAQUÍN: It wasn't all lies.

THE FATHER: I told your mum not to let you watch so many soaps.

JOAQUÍN: I won't change my story this time.

THE FATHER: I knew this was going to happen sooner or later. That's why I broke it off. He got hysterical, and ran off, straight back to his mother with all those lies and the whole sodding thing snowballed from there.

JOAQUÍN: It wasn't all lies.

THE FATHER: I never abused you. I never forced you to do anything, did I?

Pause.

But of course you're a man now and perfectly capable of lying. You lose your innocence at ten. And then there's nothing. Everything goes to shit. I don't know why I didn't finish with you sooner than I did. Look at you. Those broad shoulders, hairs in your nose. Listen to your voice, the gravel in it. Look at those feet, like you've borrowed them from someone else's body. You're even getting a little moustache, not to mention the hair you're growing down there. Do you think a boy looks good with all that hair between his legs?

JOAQUÍN: I can shave if you show me how. You know I'm a quick learner.

THE FATHER: Why would I even want to touch you when you ejaculated on me?

JOAQUÍN: But you did it on me.

THE FATHER: Because there were rules. I was the man and you were the boy.

JOAQUÍN: But I only did it that one time. I must have been ill or something.

THE FATHER: Don't lie to me, Joaquín.

JOAQUÍN: Alright, it carried on happening, but it's not my fault… and it feels nice. What's wrong with it?

THE FATHER: It disgusts me, touching another man.

JOAQUÍN: But I'm not a…

THE FATHER: Yes you are, Joaquín. You're a man now. I know it's not your fault. I know it's nature. But I don't like it, do you understand?

JOAQUÍN: No.

THE FATHER: You've got plenty of time to. Do you think it's easy for me to watch the boy I loved turn into this?

JOAQUÍN: Yes.

THE FATHER: No, Joaquín. What I felt for you only happens once in a lifetime. Do you think you're the only one who feels things? It was my first time too. I didn't touch my wife for two years. Because I was faithful to you. That's why you're still a virgin, I know about boundaries, I know what it means to respect a partner.

JOAQUÍN: So?

THE FATHER: Time destroys everything in the end, Joaquín, it doesn't matter how beautiful. Don't cry, it doesn't suit you the age you are now. You've got your whole life ahead of you, you've got time to pick yourself back up and fall in love again. I don't have that luxury. I'm old. I have to forget about my family, people, you, everyone. And I've got as much of a right to be happy as anyone – I'm not about to give up on that. Incest sickens me, even if my own family doesn't believe me, and queers sicken me even more, even if my own son is one, do you understand?

JOAQUÍN: Who's that playing in the river?

Pause.

That's who the swing's for, isn't it?

THE FATHER: I'm not a queer. I hate them.

JOAQUÍN cries like a child.